IN FOC

EUGÈNE ATGET

PHOTOGRAPHS

from

THE J. PAUL GETTY MUSEUM

The J. Paul Getty Museum

Los Angeles

In Focus
Photographs from the J. Paul Getty Museum
Weston Naef, *General Editor*

© 2000 The J. Paul Getty Trust
1200 Getty Center Drive
Suite 400
Los Angeles, California 90049-1681
www.getty.edu/publications

Christopher Hudson, *Publisher*
Mark Greenberg, *Managing Editor*

Library of Congress
Cataloging-in-Publication Data

Atget, Eugène, 1856–1927.
 Eugène Atget : photographs from the
J. Paul Getty Museum.
 p. cm.—(In focus)
 ISBN 0-89236-601-X
 1. Photography, Artistic. 2. Atget, Eugène,
1856–1927. 3. J. Paul Getty Museum—Photograph
collections. 4. Photograph collections—
California—Los Angeles. I. J. Paul Getty Museum.
II. Title. III. In focus (J. Paul Getty Museum)

TR653 .A844 2000
779'.092—dc21 00-022119

Foreword

This volume in the In Focus series is devoted to the French photographer Eugène Atget. Although heir to a documentary tradition in France, Atget compiled an exhaustive pictorial inventory of the city of Paris that is unique because he nearly always chose his own subjects rather than fulfilling governmental commissions. From modest beginnings as a collection of images—primarily of animals, plants, and landscapes—for the use of artists as preparatory sketches, his output grew to more than eight thousand pictures. They treated a wide range of subjects, all closely tied to his ideas about French culture as embodied in the buildings, streets, and parks of Paris and its surroundings.

The poignancy, if not melancholy, of Atget's photographs derives in part from his understanding that the appearance of the city and its modes of daily life were changing, often in ways that he did not welcome. Atget's achievement was to capture much of both the visible past and the present before they disappeared. His work chronicles important aspects of the transition from the nineteenth century to the twentieth.

A colloquium to discuss the work of Atget was held at the Getty Center on July 23, 1999. The participants were Gordon Baldwin, Robbert Flick, David Harris, Weston Naef, Françoise Reynaud, and Michael S. Roth. David Featherstone served as moderator and later condensed the transcript. I thank them all, particularly Gordon Baldwin for coordinating the project, writing the introduction to this book, and providing the interpretive texts for the plates that follow.

In addition to the persons named at the end of this volume, others were involved in making it possible: Julian Cox, Art Domantay, Michael Hargraves, Marc Harnly, Marcia Lowry, Ernie Mack, Marissa Nuccio, Ivy Okamura, and Fred Williams. I am grateful to them and to Weston Naef, whose idea this series was.

Deborah Gribbon,
Deputy Director and Chief Curator

Introduction

Of all the myriad of photographers' careers, that of Eugène Atget (French, 1857–1927) remains one of the most mysterious, despite considerable study devoted to it, largely because of the idiosyncratic, difficult, and enigmatic character of the man and the paucity of firsthand information about him. Biographically, what there is to mine are the letters he wrote to the institutions to which he sold work; his annotated register of clients and their wants; a short reminiscence by his sole close friend, André Calmettes (1861–1942); anecdotes by Americans who met him at the end of his life; a few photographs of the interiors of his modest, cluttered, book-filled apartment; and the inscriptions on the back of some of his images, which provide hints as to his knowledge of French history. The overwhelming body of evidence as to his life and activity is found in the approximately eighty-five hundred photographs he made. Collectively they compose a pictorial encyclopedia of the city in which he lived and that he sought to possess visually. The changing architectural, artistic, and social history of Paris, as reflected in its buildings, its streets and parks, and the ways in which its inhabitants, particularly those of the middle and lower classes, led their lives, followed customary trades, and amused themselves in public is all manifest in his work.

Atget came to his career indirectly. Born in Libourne, near Bordeaux, he lost his parents when he was very young. After attending school while living with his maternal grandparents, he was briefly a sailor, and then, entirely without

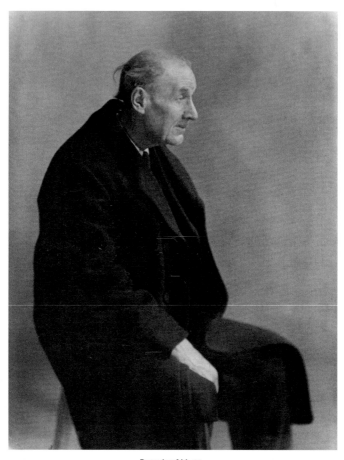

Berenice Abbott.
Portrait of Eugène Atget, 1927.
Gelatin silver print, 22.5 × 17.4 cm (8⅞ × 6⅞ in.).
90.XM.64.1.

family, an acting student and later a relatively unsuccessful actor. Permanently linked with the actress Valentine Delafosse Compagnon (circa 1847–1926), by the late 1880s he had become a photographer in Clermont, forty miles from Paris. Calmettes, who knew Atget from about this time forward, described his character as intransigent, obstinate, and independent. However, these traits did not prevent him

from having deep sympathy for the plight of the poor and, apparently, an ability to persuade strangers he encountered to allow him to include them in his urban views.

How Atget learned to make photographs is unknown, but to do so he chose to use a cumbersome, tripod-mounted view camera that utilized glass plates, although handheld cameras were available. From these negatives he made albumen prints, an already antiquated printmaking medium that he continued to employ until the 1920s, when albumen paper was no longer manufactured. Even then, when he found it, he used it. The finished contact prints show no great technical prowess or polish, particularly those from early in his career. The silhouettes of the clips that held the plates in the camera are usually visible in the photographs, and sometimes the corners are triangles of darkness because the lens did not fully cover the plate. The information conveyed by the pictures was paramount, not the vehicles by which it was delivered.

About 1890 Atget set himself up in a studio in Paris and hung out a sign that read *Documents pour artistes,* and these are what he proceeded to make, insisting, when asked, that his photographs were only that, with no further aspirations. His establishment there is the beginning of his great obsessive love affair with the city of Paris. This constant suitor daily made photographs in the streets, in parks and botanical gardens, in churches, at street fairs, and in public markets. His images were designed to serve as preliminary sketches for artists, set decorators, and designers for the building crafts, although his customers came to include associations of amateur historians, publishers, and, most important, national institutions. As his images, filled with informative and sometimes nearly inadvertently captured detail, piled up, he arranged them in series of his own devising. Among his categories were plant studies, landscapes, and reproductions of works of art. His three *Picturesque Paris* series were photographs of activities in the streets and along the Seine, of shop windows, sidewalk displays, street tradesmen, vehicles, and gypsies, ragpickers, and their dwellings. His *Art in Old Paris* group was comprised of indoor and outdoor studies of architecture and decoration, wharves, streets, courtyards, gardens, and sculpture. Another large group recorded the old royal parks that circled the city. If, as has been said, his understanding of photography was as a kind of procedural religion, then his days in the streets were a lifelong litany of preparing prayers on paper. From the early 1890s until the middle

1920s, with the exception of the period during World War I, he persevered, an increasingly aged man with a heavy camera on a solitary round.

At about the time of the death of Compagnon and shortly before his own, when he is reported to have been living on a diet of milk, bread, and sugar, Atget met the expatriate American photographer Man Ray (1890–1976), his studio assistant Berenice Abbott (1898–1991), and the soon-to-be art dealer Julien Levy (1906–81). They and the Surrealist artists championed Atget's work, beginning the aestheticization of his pictures. This maker of documents, despite his grounding in French culture, gleaned from extensive reading of literature, guidebooks, leftist periodicals, and histories, might well have thought the transformation of his patient accumulation of images into a canon of work amusingly ironic.

At its inception in 1984 the J. Paul Getty Museum's Department of Photographs had few pictures by Atget. In 1990, at the urging of Weston Naef, the initial 23 were radically augmented by the purchases of 247 images from twelve separate sources. A few more have since been acquired, and in 1994 the distinguished photographer Frederick Sommer gave the Museum 11 prints. The Atget holding now totals 295, from which were chosen the images for discussion at the colloquium and for inclusion in this book. This survey of his work can perhaps best be thought of as a highly eccentric guidebook to Paris as well as an introduction to the creations of a quirky, obsessive photographer. Reflecting the particular strengths of the Museum's collection of Atget's photographs, this overview begins with his images of Paris just before 1900 and concentrates on works from 1911 to 1912 and 1921 to 1925. Although Atget's pictures are owned in small numbers by numerous American institutions, the primary repository in this country for the study of his work is the Museum of Modern Art, New York, which, thanks to the foresight of Abbott, has 5,000 prints and 1,300 negatives. Rightly, French institutions like the Bibliothèque Nationale, the Musée Carnavalet, and the Bibliothèque Historique de la Ville de Paris, to all of which Atget sold images in his lifetime, are the great sources for his prints and often his negatives.

Gordon Baldwin, *Associate Curator, Department of Photographs*

Plates

PLATE I

Children Playing, Luxembourg Gardens

Circa 1898

Albumen print
17.8 × 20.6 cm
(7 × 8⅛ in.)
94.XM.108.11

Although it is commonly thought that a "typical" Atget photograph depicts an unpeopled scene, he created many in which people appear. They are most often simply those individuals who happened to be present in the place where he was making a view, although occasionally they seem to have been posed. Less commonly, they constitute the specific subject of a work, as seen here in one of a series of pictures, done in the Luxembourg Gardens, that seem designed to show how the public used these spaces. Of the seven foreground figures, three are evidently aware of Atget and the camera: the nanny is clearly suspicious of the photographer's intentions, the boy on the run in a sailor middy and high-laced boots is nonchalantly curious, and the standing girl with a sand shovel to her mouth is puzzled. Her three companions scratching in the dirt with their shovels are oblivious, and the well-bundled-up toddler is intent on her shovel and its tablespoon of sand. They are overlooked emblematically by a statue of one of the queens of France and more prosaically by a row of seated nurses with their charges. Other figures are lost in the shadows of the path that leads into the distance.

This image was made relatively early in Atget's career as a photographer and straightforwardly portrays Parisian life of the period rather than inventorying a more concrete facet of its past. With the passage of time, however, the photograph has become a document of historical interest, if for no other reason than the clothing it records. Children today still play in the Luxembourg Gardens and are still overseen by watchful guardians, but clothing is far less formal now, and toys are apt to be of plastic, not metal or wood.

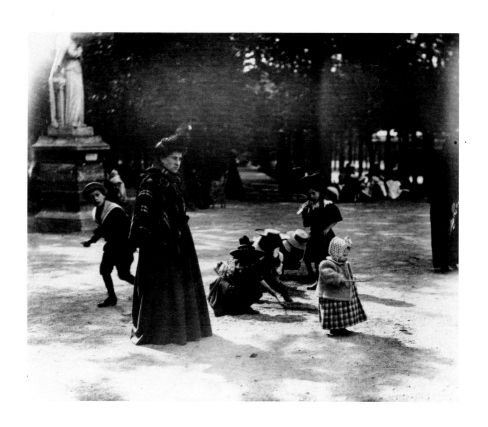

PLATE 2

**The Old School
of Medicine,
rue de la Bûcherie**
1898

Albumen print
21 × 17.6 cm
(8 ¼ × 6 ¹⁵⁄₁₆ in.)
90.XM.47

Atget's quest for the architectural remnants of the past embedded in the fabric of the city of his time led him to photograph the domed corner of this deceptively small building. When it was constructed at the beginning of the sixteenth century to house the nascent medical school of the University of Paris, a large room in the dome housed an amphitheater in which classes were taught. After considerable and continual modifications to the building in the following two centuries, the medical school gave it up in 1810. In Atget's day part of the structure was used as a residential hotel, while a wine shop occupied the corner on the intersection. A mezzanine had been inserted into what were originally two-story spaces, perhaps to produce more furnished rooms to rent. The city of Paris bought the building two years before Atget photographed it, and after alterations in 1910, it served as school housing and then as a library. The

building today looks far less picturesque, as it has been thoroughly restored to match its original severe appearance. The shutters, angled chimney flues, and wine shop are gone, and the stone has been scrubbed of paint. Underneath the oversize rococo eyebrow at the right, which in 1898 preposterously overarched two little windows and a pair of merging drainpipes, there is now a great round-topped window like those that lit the original classrooms. The building presently contains the city's school of administration.

Atget's view is alive with quiet incident, from the blurred image of the woman rummaging at the vegetable barrow to the man hesitating on the corner to the dog nosing at the sidewalk. More figures are dimly visible farther in the distance. Atget's instinct to photograph the building as a souvenir of the past was prophetic, for it did not long remain as it was.

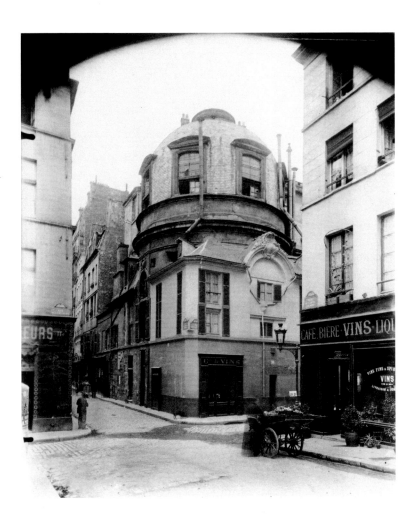

PLATE 3

The Facade of
Saint-Julien-le-Pauvre
1898

Albumen print
21.7 × 17.7 cm
(8 %₁₆ × 7 in.)
90.XM.123

When Atget photographed the front of the venerable church of Saint-Julien-le-Pauvre, other buildings hemmed it in. (Those on the left have now mostly been removed.) The setting seems medieval, reflecting the origins of the church. The sixth-century chapel here was destroyed by the Normans in the ninth century and was ultimately replaced by a church and priory constructed between 1170 and 1240 in a style transitional from the Romanesque to the Gothic. Remnants of this architecture are visible on the left. While serving as the parish church of the University of Paris, it was sacked in 1524 by students unhappy with the results of an election held there for a new rector of the schools. When the dilapidated church was reconstructed in 1651, the first two bays of its nave were eliminated and the present simple facade erected. The scars on the Doric pilasters of its face are the marks of buildings attached to it when it was used for salt storage during the French Revolution.

After functioning as a wool depot, it was reconstituted as a church in 1826 and transferred to the Greek Melchite rite in 1889, whose congregation it still serves.

Atget's image is shaped by the arched area at the top of the photograph, caused by the incomplete coverage of the glass-plate negative by the lens. The eye is led back by the central gutter in the tilted paving stones of the street toward the facade until the drain veers left. The eye shifts to the church's guardian, comfortably seated by the open doors at the entrance and gazing straight at the camera. As the ground around the church is now higher than when it was built, one steps down into the church, a mark of its antiquity. The battered, darkened stone; sloping, rough-edged paving blocks; and confining walls create a nearly palpable sense of claustrophobia, a kind of nightmare where the only exit is to plunge into the blackness of the church.

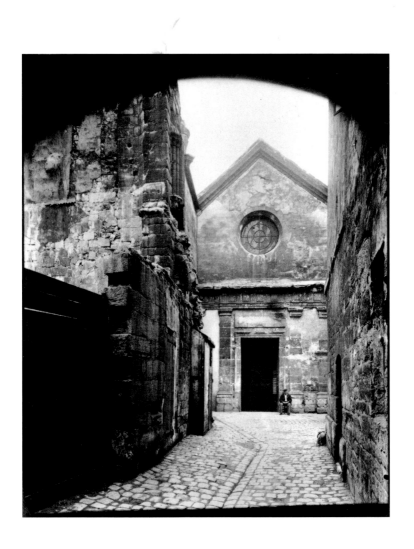

PLATE 4

Place Saint-Médard
1898–99

Albumen print
21.9 × 18.1 cm
(8 ⅝ × 7 ⅛ in.)
84.XM.1034.1

A logical extension of Atget's interest in docu-
menting how merchandise was purveyed,
whether in shop displays or by street ven-
dors, was to make this sunny general view
of a busy square, the site of an outdoor
market in front of the twelfth-century church
of Saint-Médard. The market came into
being after 1875, when the square was laid
out on land that had once been part of a
cemetery that surrounded the church. In 1898
and 1899 Atget frequently photographed
here. Most of his images were studies
of individual sellers, whether of artichokes,
flowers, herbs, umbrellas, or baskets, and
there are a few pictures in which stiffly
posed customers pretend to buy. Other views
encompass multiple stands set up along
the market's edges, with many vendors and
customers seemingly oblivious to Atget's
camera. This, however, is the most overall
prospect of a neighborhood in which the

adjacent streets were a center for the sale
of foodstuffs and household paraphernalia.
Although several of the passersby carry
baskets and parcels, the height of market
activity seems to have passed, and the stalls
have been taken down. It is perhaps close
to noon, and the crowd is dispersing to
apartments and restaurants for lunch, leav-
ing the square and its wall of advertisements.

Although some of the trade once
carried on in the square has now been dis-
persed into neighboring streets, which
are closed to vehicular traffic, a lively meat,
fish, and produce market still occurs in
part of the place Saint-Médard. However,
the billboard-scale advertisements that once
dominated the view have vanished, and
a tiny grass-covered park with sizable trees
now fills some of the space. The urban
fabric continues to evolve.

PLATE 5

Staircase,
Hôtel de Brinvilliers,
rue Charles V
1900

Albumen print
22.2 × 17.7 cm
(8¾ × 7 in.)
90.XM.64.140

Besides the street views for which he is famous, Atget made numerous photographs of Parisian interiors, including systematic documentation of churches—chapel by chapel, altar by altar. There are also studies of rooms in residences belonging to a cross section of the middle class and several images of staircases in mansions built by the aristocracy. This graceful flight of stairs sweeps downward from darkness into the entrance hall of an elegant house, constructed in 1630. The light comes from the windows and door next to which Atget placed his camera. By the time that he photographed the staircase, the building was visibly run down, the plaster and stonework stained and sooty, the paving tiles scuffed and dirty, and the hall disfigured by an ugly furnace. However, the wrought iron of the railing that spirals upward in zestful curlicues retains its loveliness. It is not possible to tell whether the opening in the alcove under the steps leads to a broom closet or a basement.

On the back of the photograph Atget wrote the word *l'empoisonneuse,* "a woman who poisons," which reveals that the historical associations of the house mattered to him. The poisoner was the infamous Marquise de Brinvilliers (circa 1630–76), who had married into the family that built the home. While in residence there, she bore three children of uncertain paternity and three by known lovers. Her principal paramour helped her to devise and employ a concoction of arsenic, toad venom, and vitriol to poison her father and two brothers. Her attempts on the lives of her husband, sister, and children's tutor were unsuccessful. Having unwisely written accounts of her misdeeds, which also included arson and incest, she was apprehended, tried, and, having been found guilty, beheaded, burned, and her ashes thrown to the wind.

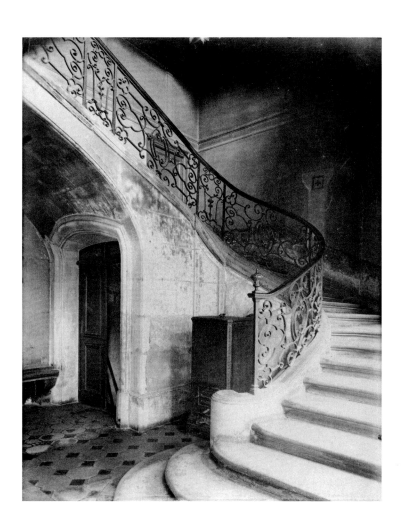

PLATE 6

Shop Front,
rue Michel-le-Comte
1901

Albumen print
21.5 × 17.5 cm
(8⁷⁄₁₆ × 6⁷⁄₈ in.)
90.XM.64.46

Atget photographed this shop front primarily in order to record the seventeenth-century wrought iron sign depicting a pulley, shallow bucket, and rope. The liquid to be drawn up "At the Good Well" (Au Bon Puits) was not water but wine. The establishment was for a long time a famous cabaret, which closed in 1906, five years after Atget made this view. Its marker, however, was salvaged and is now part of a collection in the Musée Carnavalet of shop signs that used visual symbols rather than words to announce wares to members of the public, only some of whom were literate in the 1600s. Atget made a series of photographs of these signs, which he recognized were in the process of disappearing (see also pl. 10).

It seems likely that the silhouette seen in the windowpane just to the right of the door handle is the reflection of the photographer in the street standing sideways to his camera and tripod, which can indistinctly be seen in the center pane (see detail on p. 99). Judging by the height of the handle, the figure is some distance away from the door, far enough so that if he were inside the shop he would be lost in shadow. This makes the picture a discreet but not unintentional self-portrait. Given the large number of photographs that he made of storefronts, fragmented reflections of Atget or his camera occasionally occur, but these other glimpses seem incidental, not purposeful.

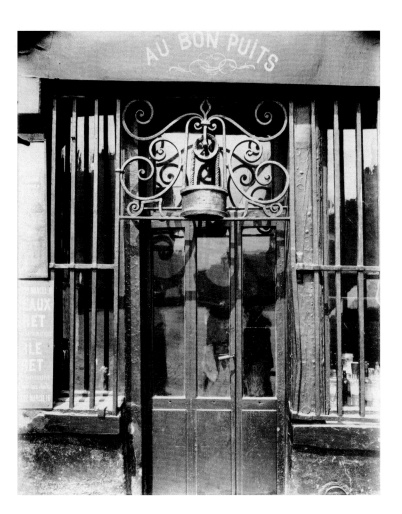

PLATE 7

Lampshade Vendor, rue Lepic
1901

Albumen print
22.3 × 17.8 cm
(8¾ × 7 in.)
94.XM.108.4

When Atget turned his attention to photographing *les petits métiers* (street tradespeople), he was adhering to a long iconic tradition in French graphic arts. Artists like Abraham Bosse in the seventeenth century, Edmé Bouchardon in the eighteenth century, and Carle Vernet in the nineteenth century took these outdoor sellers as subjects for their engravings, etchings, and lithographs. Nineteenth-century photographers like Charles Nègre and Humbert de Molard also made images of such tradespeople, as did photographers of Atget's generation, like Paul Geniaux and Louis Vert, but Atget was more thorough, portraying a larger variety of peddlers. As their livelihood depended upon their not going unnoticed, these inherently picturesque hawkers with their singsong street cries were available and seemingly willing subjects.

This vendor of lampshades in the streets of Montmartre is typical of these tradespeople, who also included ragpickers, knife sharpeners, window washers, dispensers of coconut milk, and sellers of baskets, herbs, candy, and plaster statues. (The lampshades he displays were intended for gas lamps, not electrical fixtures, which explains their uniformly small scale.) Atget's series of works depicting these individuals was made over a short span of years, from 1899 to 1901, but unlike his other series, he did not revisit this one. As he intended, artists used some of the images as sources for works in other media. Additionally, about 1904 a Parisian publisher released a set of eighty postcards of Atget's photographs of *petits métiers,* a unique occurrence of the wholesale commercial adoption of his pictures.

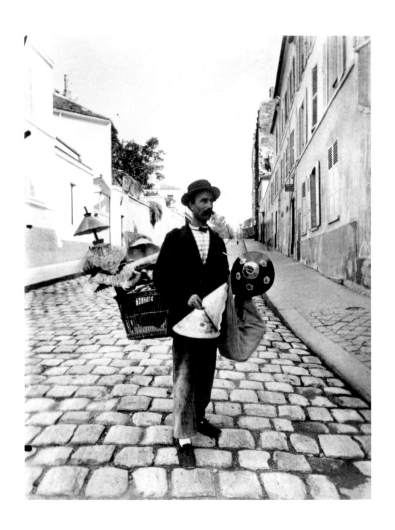

PLATE 8

Ragpicker,
avenue des Gobelins
1901

Albumen print
22.3 × 18.1 cm
(8 ¾ × 7 ⅛ in.)
90.XM.127.4

The man who pulls this cart of bundled rags and trash has consented to pose for Atget but eyes him distrustfully, wondering perhaps why the photographer has chosen him to become the subject for the camera. Because Atget made four or so images of *petits métiers* at this location, at least three all on the same day, maybe it was explained to the ragpicker and the others that the artist was making a series of pictures of street tradespeople, and his sitters met him by appointment. (It is highly unlikely that Atget simply waited for appropriate subjects to pass by and that on one lucky day three or four appeared.) If sittings were prearranged, then might the subjects also have been paid? Perhaps not in this case, as the ragpickers, these untouchables in the class system, were notoriously independent and proud. In addition, Atget in 1901 was not

rich. However he came here, the ragpicker did not trouble to shave and wears his ordinary work clothing. As has been pointed out by Maria Morris Hambourg, it is not the person but the trade that is being portrayed. Hence Atget did not tell the model to turn his head to free half his face from deep shadow. Nor did Atget make any attempt to show the surroundings—the background is wholly out of focus. It was enough to place the ragpicker in the street and carefully position him so that he and his crude two-wheeled cart, its cargo tied in place, filled the frame.

Fulfilling Atget's intention for the employment of his photographs, this image was used not only as one in a series of postcards (see entry for pl. 7) but also as the model for a wood engraving by Jacques Beltrand (1874–1977).

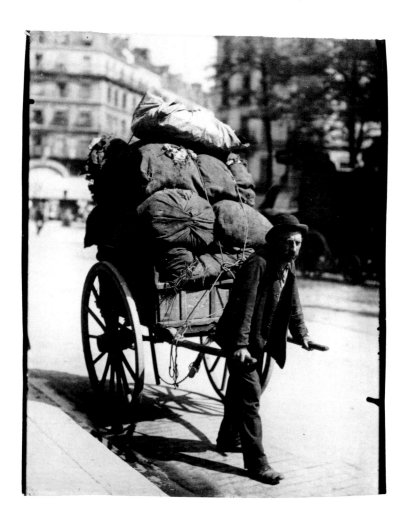

PLATE 9

Fountains at Juvisy

1902

Albumen print
17.7 × 21.9 cm
(7 × 8⅝ in.)
90.XM.64.37

The pair of majestic fountains that frame this view of a road disappearing into the distance are at one end of a monumental bridge at Juvisy, on the highway from Paris to Fontainebleau. The bridge, fountains, and their sculptural finials were erected in 1728 by order of Louis XV as part of his campaign to improve and embellish French thoroughfares. The discovery of springs during the course of excavations for the foundations of the bridge prompted the decision to divert the water to create two fountains for the refreshment of dusty travelers and their horses. At the time of Atget's picture, water still flowed into the basins from spouts in the form of grotesque masks. Atop the fountain on the left is an allegorical sculpture depicting Time holding a portrait of the king, the revelation of which has the effect of crushing Discord. It was chiseled by Guillaume Coustou (1677–1746), who may also have been responsible for the simpler group that crowns the other fountain. Atget's notation on the print that it depicts "the beautiful fountains" reflects the fact that they were known by this appellation from early on and is an indication of how deeply steeped he was in French cultural history.

Unlike the tight spatial constraints seen in many of Atget's photographs, taken as most of them were in urban settings, this image offers a long vista vanishing at the horizon. Even in his pictures of the gardens of the old royal palaces, he rarely chose to make axial views along their avenues into the distance. The result here is a prospect without limits, a sense of the road stretching out infinitely before the traveler, reaching beyond the familiar and immediate to the unknown. Left unresolved, however, is the question of how Atget arrived with his equipment at this seemingly remote location.

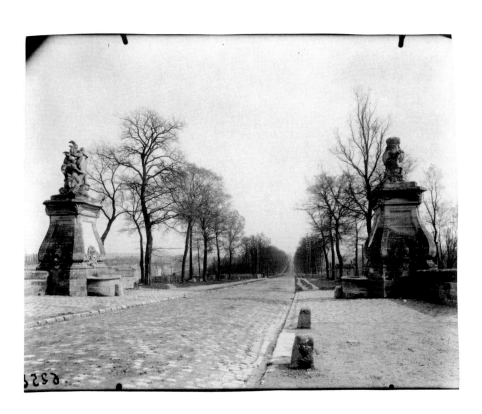

PLATE 10

Storefront (Little Bacchus), rue Saint-Louis-en-l'Ile

1901–2

Albumen print
22 × 17.8 cm
(8 ¹¹/₁₆ × 7 in.)
90.XM.124.13

In this print, a woman, reminiscent of a figure by Vermeer, peers appraisingly through the glass panes of a storefront doorway at Atget in the street (see detail on p. 138). Dimly visible behind the center pane is a tabletop, seemingly set for a meal. As the woman wears an apron, it can be surmised that she is an employee of the establishment. Possibly on a break from her job, she appears curious as to why the entrance to her workplace is the subject for a photograph. Her fortuitous presence gives human scale to the architecture and adds a note of mystery to the picture.

Over the door, the sculpture of a baby Bacchus, the god of revelry, astride a wine cask surrounded by grapevines laden with fruit announces this store as that of a wine merchant. Atget's reason for photographing it was governed in part by a widespread revival of interest at the turn of the century in the history of the city. Neighborhood antiquarian societies, national libraries, and private collectors of material concerning *Vieux Paris* (Old Paris) would all have been likely customers for such an image. Somewhat surprisingly, this seventeenth-century sign still survives in situ. The sign and storefront are designated landmarks and now mark the entrance to a restaurant.

About seven years after creating the picture, Atget made a detail from a section of it (see p. 114) in order to show at a larger scale the figure of Bacchus, the grapes he proffers, the wine bottle he holds, and the elaborately worked iron of the twining vines. Rephotographing the original print softened its crispness, but the existence of the detail confirms that Atget's overriding intent was in recording the embellished sign rather than the storefront per se.

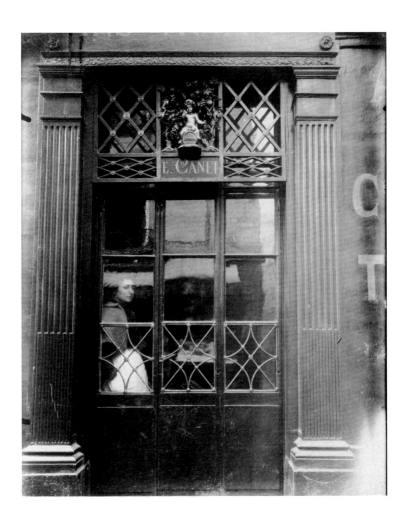

PLATE II

The Temple of Love,
the Petit Trianon

1902

Albumen print
21.4 × 17.8 cm
(8 7/16 × 7 in.)
90.XM.64.38

This twelve-columned neoclassical pavilion was commissioned by Marie Antoinette in 1778 from the architect and decorator Richard Mique (1728–94) to adorn the gardens of the Petit Trianon at Versailles. Derived from the Temple of the Sibyl at Tivoli, outside Rome, it housed a copy of a statue by Edmé Bouchardon (1698–1762) of Cupid carving his bow from the club of Hercules. Atget made another view of this garden ornament seen through a screen of foliage as well as one of a companion pavilion, the octagonal Temple of Music, which the queen had ordered from the architect at the same time. Like her nearby mock dairy farm and the Petit Trianon itself, these two intimate shelters were refuges from the grandeur of Versailles, which dominates the park in which they all stand.

Atget contrasted the white forms of the rigidly geometric temple with the irregular dark shapes of the limbs of the tree in the foreground, a direct confrontation of the artificial with the natural. The pavilion, a sad souvenir of a fallen regime, is dwarfed by the tree, a durable embodiment of a more permanent form of life. No stone acorns will fall to seed new temples.

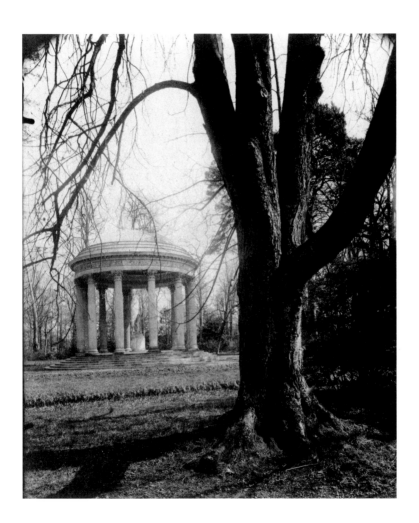

PLATE 12

Antique Store, rue du Faubourg-Saint-Honoré

1902

Albumen print
21.8 × 17.9 cm
(8⁹⁄₁₆ × 7¹⁄₁₆ in.)
90.XM.120

Atget's study of the elegant Empire-style facade of this storefront on the fashionable rue du Faubourg-Saint-Honoré captures only one phase in the architectural history of a building originally constructed in 1776 as a double private house. This section was sold in 1787 to an apothecary, who probably transformed the front of it into a shop. When Atget photographed the structure in 1902, the original windows with small panes had been replaced by plate glass, and the building served as an antique store. By 1920, having been briefly a dress shop, the place was dilapidated. The arrows that fan out in the upper glass had mostly lost their vanes, the arched lettering had been removed, and the retail space stood empty. Today, its facade now altered beyond recognition, the building houses an expensive British purveyor of hunting gear.

The broad expanses of glass provide a glimpse of the antiques in the interior, including clocks, fans, a ewer, and a table, but also reflect the sunlit street. Besides a lamppost, awning, and pushcart, Atget himself, hat on head, can be found (see detail on p. 96). One of his hands is held up to the camera on its tripod, which is partially covered by the black cloth under which he examined the image on the ground glass before making the exposure. At one foot of the tripod is the satchel that holds the glass plates for the camera. The photographer is caught at the moment of making this picture, a simultaneous portrait of a storefront and of himself in action.

PLATE 13

House on the place du Caire
1903

Albumen print
22 × 17.8 cm
(8 ¹¹/₁₆ × 7 in.)
90.XM.127.3

An architectural fantasy rises out of the black foreground of this photograph, the curious main facade of a house built in 1799, just after the square it fronts was laid out. Its style was, no doubt, the result of an interest in things Egyptian, spurred by Napoléon's expedition to Egypt the previous year. His capture of Cairo led to the square and an adjacent street being named for that city, even though his attempt to annex the country failed. The three sphinx heads, the frieze of warriors and horse-drawn chariots, and the arched windows, which are vaguely Moorish in inspiration, are architectural oddities, attempts to appropriate ancient and alien elements to the front of a conventional building. On the ground floor there were originally six columns with lotus capitals separating the entrances to small shops and a pedestrian arcade. By Atget's day only three remained, the others having been sacrificed to commercial dictates.

In addition to the neo-Egyptian decorations, the camera also recorded details of daily life. Evidently Atget and his camera attracted the attention of the waiter, two customers, and boy in front of the street-level restaurant on the left, as all of them are looking toward the photographer (see detail on p. 141). A fast-moving woman in the center left merely a blur as a record of her passing, the result of the long exposure time. The balance of the ground floor and half the mezzanine above were occupied by a printing company, the hand-drawn delivery cart for which is at the curb. A large sign above the sphinxes advertises that an apartment in the building was for rent as either a comfortable dwelling or a place of business, with application being made to the concierge.

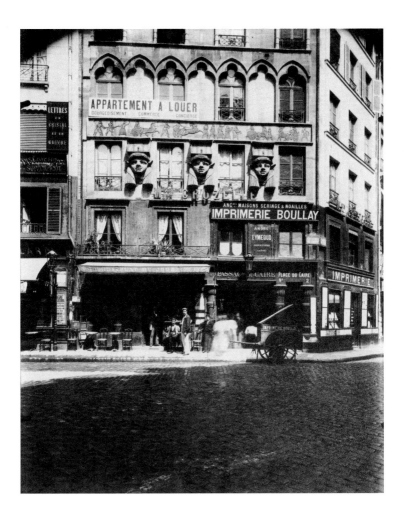

PLATE 14

Courtyard of Farewells, Fontainebleau

1903

Albumen print
21.9 × 17.7 cm
(8⅝ × 7 in.)
90.XM.121

This photograph depicts the famous horse-shoe-shaped staircase that sweeps up to what was once the principal entrance of the royal château of Fontainebleau. The palace, forty miles outside Paris, was erected, enlarged, and embellished by a succession of monarchs over a period of more than three hundred years. Only Versailles and the Louvre are larger. The stairway was built by Jean Du Cerceau (1585–1649) in 1632 to replace one on the verge of collapse. It stands at the head of a long enclosure, called either the Courtyard of the White Horse, because of an equestrian statue that once stood in it, or the Courtyard of Farewells, because of Napoléon's emotional 1814 farewell address there to his imperial guard after his first abdication. The man in the dark jacket and light trousers at the foot of the stairs, no doubt a state employee, waits for tourists to appear.

Atget rarely made such specific views of royal palaces, although they can often be seen in the backgrounds of his numerous photographs of their surrounding gardens. Perhaps his many pictures of the staircases in Parisian houses (see pl. 5) led him to this subject. The steeply angled perspective of his view and the compression created by the lens make the building loom above the expanse of paving stones. The presence of the guide and the open windows in the château give life to what might otherwise have been an image of frigid majesty.

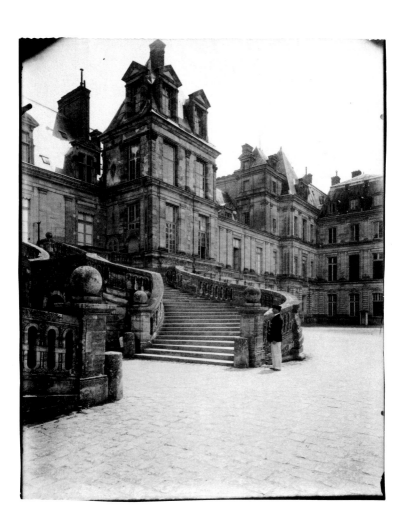

PLATE 15

Tollgate, place du Trône
1903–4

Albumen print
17.4 × 21.7 cm
(6⅞ × 8⁹⁄₁₆ in.)
90.XM.64.168

Atget's photograph depicts one of a pair of pavilions and columns that composed an ensemble that was part of a series of forty-seven formal gateways in the wall that circled Paris at the end of the eighteenth century. The pavilions, constructed in 1787, were designed by Claude-Nicolas Ledoux (1736–1806) and housed offices for the collection of taxes on goods being brought into the city. Their flat roofs and ponderous forms are largely due to the fact that they were intended to be the podiums for monumental columns, which were built, instead, to the side. The columns had sentry boxes in their bases and were linked to the customs houses by metal grilles, which had vanished by the time of Atget's view. This site, where more than one thousand people were guillotined during the Reign of Terror, is now the place de la Nation, a principal crossroads of the modern city rather than its eastern limit.

The upper edge of the photograph is shaped by rounded corners, the result of Atget's lens not fully covering the area of the glass-plate negative, and is punctuated by the traces of two of the clips that held the plate in place inside the camera. Both arcs and clip marks frame the scene like a stage proscenium, suggesting that the third act of Puccini's opera *La Bohème*, which is set at dawn at a Paris tollbooth, has concluded, its characters dispersed. Atget may have wanted to commemorate this elaborate tollgate because he thought that it would be demolished, as were forty-three of the original forty-seven. This one has survived to the present day.

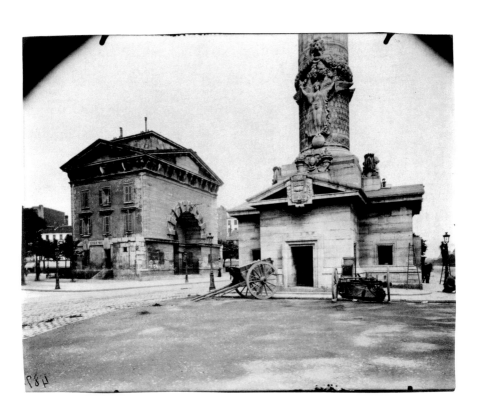

PLATE 16

France Triumphant, Versailles

1904

Albumen print
21.7 × 17.6 cm
(8 9/16 × 6 15/16 in.)
90.XM.64.59

The gardens of the royal château at Versailles are well supplied with sculptures, among them this monumental group depicting France triumphing over both Austria and Spain. The central, somewhat lifelessly composed, helmeted figure, seated in a ceremonial chariot, represents France. Her shield bears three fleurs-de-lis and the sun of Louis XIV, whose military successes are the subject of this celebration. The foreground male figure, seated on an eagle, symbolizes a defeated Austria and the Holy Roman Empire it then headed, as is indicated by the classical armor and fallen helmet. (When the fountain that this sculptural group surmounted was in operation, water spouted from the beak of the crushed eagle.) The ensemble, originally gilded and set in an elaborate architecture of shaped shrubbery, was the joint work of Antoine Coysevox (1640–1720) and Jean-Baptiste Tuby (1635–1700). Completed in 1683, the fountain was restored in 1883 and perhaps again later.

This image of the work is one of at least five that Atget created. The first, presumably, was an overall view made with the camera set directly facing the central sculpture. Next he made two studies of each of the side figures: this one of Austria and a second, closer one, and then, in parallel fashion, two of Spain. The majestic effect that the sculptural group was intended to have is undercut in this photograph by the bare branches of the trees and the fallen leaves that litter the steps and molder in the basin. Resplendent grandeur gives way to autumnal sadness. The meaning of the monument, which Atget no doubt understood, fades in the approaching haze of winter.

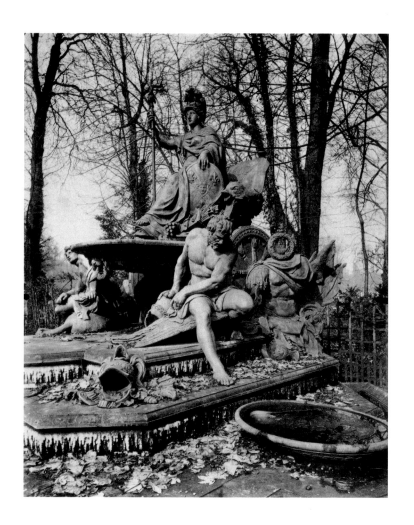

PLATE 17

Palais Royal

1904–5

Albumen print
21.9 × 17.9 cm
(8⅝ × 7¹/₁₆ in.)
90.XM.64.128

The severe elegance of this photograph of two of the arches of an arcade running along one of the sides of the garden of the Palais Royal in Paris is unusual in Atget's work. Because of its near symmetry and lack of discernible perspective, save in the foreground paving, the image seems more like an architectural elevation than a photograph. Atget probably hoped to sell it to architects who would find it useful for the information it gives about the building's proportions and details. However, the photograph is not quite balanced, as two flutes more of the pilaster on the left are visible than of the pilaster on the right. The top edge of the photograph crops a line of balusters over each arch in such a way that they appear to be rows of beads. Very early, delicate, and shapely examples of gas lighting fixtures hang in the arches; beyond are visible the shuttered windows of one of the stores lining the arcade.

Atget made several views of the palace, its garden, and the arcades in the early 1900s. The last were designed by the architect Victor Louis (1731–1800) for Philippe Égalité (1747–93), a cousin of Louis XVI. Égalité, in the course of the French Revolution, infamously voted for the king's execution but was subsequently guillotined himself. In need of money in 1781, he had enclosed three sides of the large garden that ran beyond his family palace with arcades housing shops that would produce income. In the three stories above were apartments that were rented out for additional monies. They continue to be desirable residences today, looking out as they do on a tranquil and spacious garden in the heart of the city.

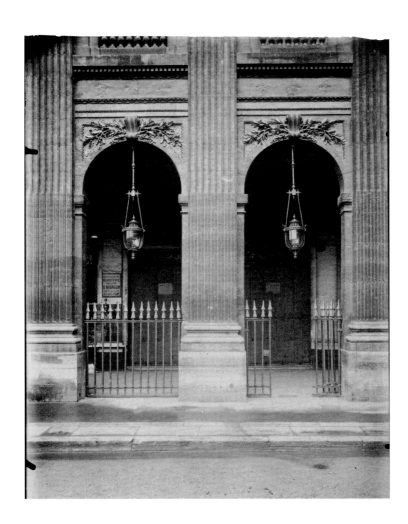

PLATE 18

Tree Roots,
Saint-Cloud

1906

Matte albumen print
22.3 × 17.2 cm
(8¾ × 6¾ in.)
90.XM.64.25

Resembling an Art Nouveau drawing, the
sinuous roots of this tree snake about a
rock at the foot of a wall in the old royal
park of Saint-Cloud, outside Paris. This
picture is one of a group of studies of tree
roots that Atget made in this park in 1906.
His views of trees are common, of their
roots, rare. It has been suggested that his
images of components of trees may relate to
his contemporaneous experience in photo-
graphing increasingly specific details of
architectural elements. More fancifully (and
anthropomorphically), as a tenacious man
Atget may have admired the articulation
of the tree's elaborated system for survival,
both drawing up nourishment and anchor-
ing itself to the ground. In any case, by
making this study of the interwoven organic
textures of wood, stone, crumbling leaf,
and earth, Atget expanded the range of
the documentary photograph to include an
unexpected subject seldom treated by
other photographers. The seemingly com-
monplace aspect of this image gives it a
surprising modernity.

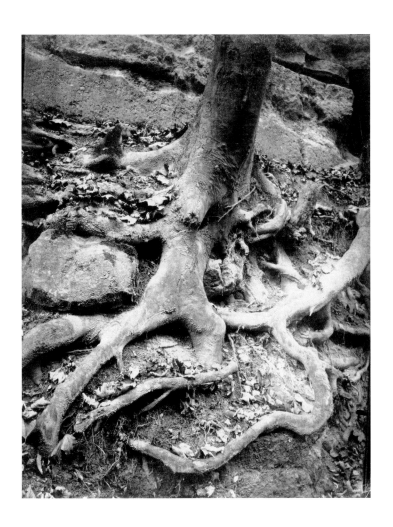

PLATE 19

Produce Display,
rue Sainte-Opportune

1920s gelatin silver print
from a 1908 or 1912 negative
22.5 × 17.8 cm
(8⅞ × 7 in.)
90.XM.64.19

One of the persistent themes in Atget's
work is his attention to the ways merchan-
dise was presented on the streets of Paris
to potential consumers, particularly of the
working class. This store, located on the
minuscule rue Sainte-Opportune, around
the corner from Les Halles, which was
then the great central market of Paris, went
to some trouble to arrange its fresh pro-
duce in a tidy fashion. To increase the attrac-
tiveness of the fruit and vegetables, the
display containers were carefully lined
with folded newspapers or white paper, no
doubt replaced every day, and the shelves
beneath them were covered with additional
paper. As is often the case in Atget's photo-
graphs, the image conveys considerable
information that is incidental to his primary
focus. While the principal subject is the
produce display, the lettering on the window
advertises that this establishment also sold

butter, eggs, cheese, whipping cream,
sardines, preserves, and pasteurized milk,
which was delivered twice daily. Just
as this picture is an inventory of the grapes,
peaches, plums, broccoli, and pears avail-
able from this particular vendor, so also was
Atget's series of sidewalk displays an in-
ventory of the inventiveness of shopkeepers
in presenting their wares to the public.

Atget arranged his negatives in roughly
chronological order in a series of compli-
cated sets according to subject. The inscribed
number on this photograph's glass nega-
tive indicates that it was created in either
1908 or 1912. The print was made on gelatin
silver chloride printing-out paper, which
Atget did not employ until the 1920s. The
whiplash lines in the lower left corner of
the print indicate that the negative was
damaged after its creation, but Atget evidently
still found it worth printing.

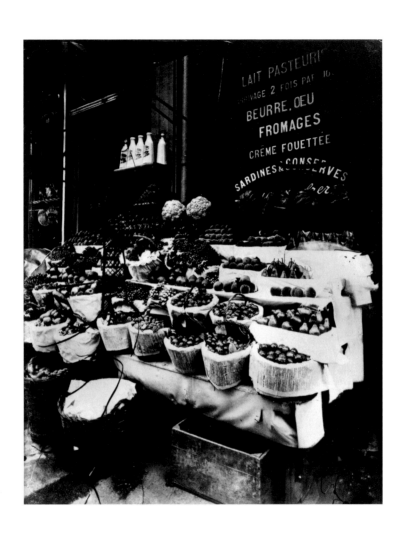

PLATE 20

Water Lilies

1910 or earlier

Albumen print
22.1 × 18.2 cm
(8 ¹¹⁄₁₆ × 7 ³⁄₁₆ in.)
90.XM.64.45

In order to produce the "documents for artists" that the sign at his door advertised, it was necessary for Atget to be aware of what the subjects of contemporary art were and to gauge what kinds of images would be useful to painters, illustrators, set and fabric designers, and interior decorators in making their own work. It is tempting to think that this image of water lilies derives directly from Atget's awareness of Claude Monet's grand series of paintings of the water lilies in his garden at Giverny, which the artist began in 1899. However, there are no known associations between the photographer and the painter.

Studies of plants were a recurrent theme in Atget's work, dating from the pictures of about 1900 of apple trees in bloom to those of nasturtium leaves in the 1920s.

The white disk of an identifying plant marker that can be seen in the lower left quadrant of this photograph indicates that it was made in the botanical garden of Bagatelle, a park on the outskirts of Paris.

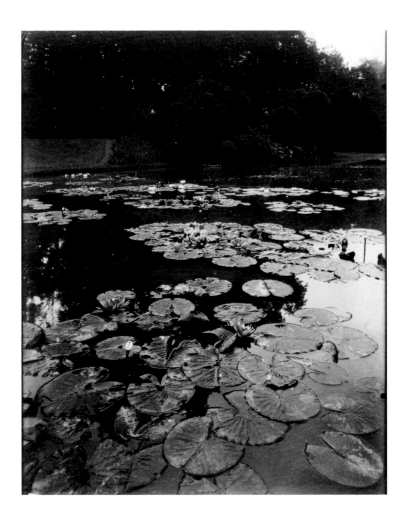

Old Courtyard, rue Quincampoix

1908 or 1912

Albumen print
22 × 17.4 cm
(8 ¹¹/₁₆ × 6 ⅞ in.)
86.XM.628

Metalworker's Shop, passage de la Réunion

1911

Albumen print
21.6 × 17.7 cm
(8 ½ × 7 in.)
90.XM.64.133

Tinsmith's Shop, rue de La Reynie

1912

Gelatin silver print
22.6 × 17.8 cm
(8 ⅞ × 7 in.)
84.XM.1034.5

These three bleak views document the commercial use by the urban working class of cramped public or quasi-public spaces. In plate 21, in what was originally the private courtyard of a sixteenth-century house, a small enterprise that advertised that ironing was done "most amiably" shares the alley with several apartments, evidenced by the rags hung out to dry, the baskets on pegs, the houseplants on windowsills, and the two figures in the central window. It is a measure of the gloom in this space that during the long exposure that it took to record details of the courtyard, the comparative brilliance of the sunlight in the street outside caused the view through the rectangular portal to be overexposed. To leave by that doorway was to exit into a larger, brighter world.

In plate 22, the jaunty stance of a smiling, muscular metalworker in his smithy on the passage de la Réunion contrasts with the stiff pose of the woman, presumably his wife, who is displayed like a doll in a box in the window above. Evidently their home and workshop were bundled together at the beginning of this squalid, nine-foot-wide public passageway. In plate 23, the implements from a tinsmith's shop have spilled out onto the sidewalk. Judging by the tools on the windowsill and the scraps on the pavement, the smith worked in the street itself, traffic permitting. Teapots, various pots and pans, and a large, round basin hang next to the darkened shop door and grimy window. A barrow for picking up damaged goods and delivering mended utensils rests in front. These three pictures are not only documents of specific urban spaces but also poignant studies of the differing textures of battered and abraded stone, dented and scarred metal, and light reflecting from dull surfaces.

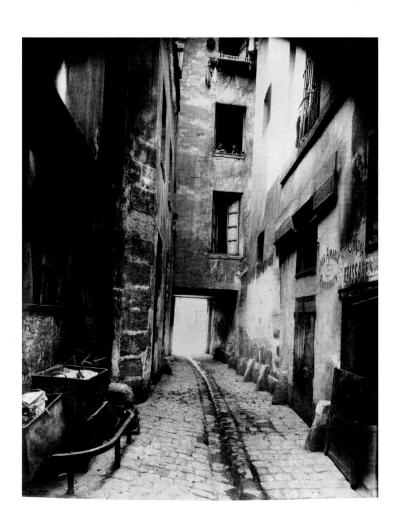

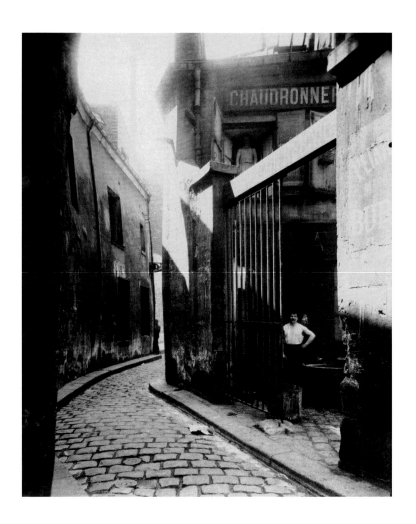

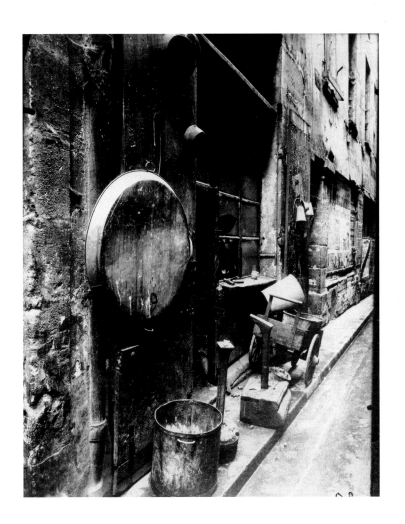

PLATE 24

Costume Shop,
rue de la Corderie

Circa 1920 matte albumen
print from a 1911 negative
22.5 × 17.9 cm
(8⅞ × 7 1/16 in.)
84.XM.1034.4

Atget's interest in depicting how merchandise was presented extended to this extremely modest commercial enterprise, a costume shop, which is apparently tucked into the ground floor of a residential structure. Its means of display are of the greatest simplicity. At the left end of a rod that runs over the shop window and door dangles a clown costume, followed by others for roles that cannot be discerned. A child's Zouave jacket hangs from a little bracket next to the door; other vestments are suspended from the awning and its supports. More merchandise is simply piled or boxed on the two chairs on the sidewalk, under one of which sits a striped cat (see detail on p. 144). The shelves of the shallow store window are stacked with masks, crowns, a helmet, Turkish slippers, and other theatrical items. A stained table in the foreground seemingly awaits additional goods to be displayed. Whatever its one-time commercial viability, the costume shop and the house above it are now gone, replaced by a brutally unattractive apartment block.

As is often the case, Atget's activities are observed by the neighbors. Across the side street beyond two pushcarts a man in a white duster, apparently the proprietor of a secondhand clothing store, looks toward the camera. A jumble of used garments is piled beside him and suspended overhead. Beneath the barrows a blur marks the ghostly image of a child seated on the curb, elbows akimbo, who moved during the course of Atget's exposure. In the left-hand window on the fourth floor of the white building a woman peers down into the street. The inclusion of these people is incidental to Atget's purpose, but they animate the scene and give a sense of local life in fair weather.

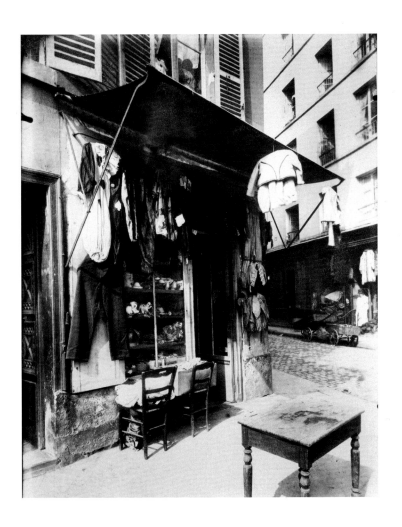

PLATE 25

**Hairdresser's Shop
Window, boulevard de
Strasbourg**

1912

Gelatin silver print

23 × 18 cm

(9 ¹/₁₆ × 7 ¹/₁₆ in.)

90.XM.64.20

Framed in Art Nouveau tendrils, this estab-
lishment proffers a wide variety of services
to do with hair. Although the disembodied
mannequins are all female, the sign at
right advertises that in rooms reserved for
men, shaving, beard trimming, haircutting,
and shampooing, wet or dry, are available.
For women, hairdressing could be obtained
as well as wigs, both full and partial.
To make these hairpieces more alluring
to potential customers, the busts in the
window are elaborately draped with shim-
mering or diaphanous material in order
to create the plunging necklines fashionable
during the period and are set on little ped-
estals with satin ruffled covers. At the front
of the window, displayed on headless fore-
heads, are rows of wiglets, to be had either
waved or fringed in a variety of colors. The

tasseled shade at the top of the window, to be
let down after hours, resembles the curtain
called a teaser at the top of a proscenium
arch and reinforces the theatricality of the
kohl-rimmed eyes of the painted ladies.
Apparently a perennially popular site to cut,
style, or imitate hair, the somewhat seedy
present-day boulevard de Strasbourg con-
tains numerous hairdressers' shops, nearly
all of which bill themselves as unisex salons.

Although there are dim reflections in
the window glass, it was only later in Atget's
career, after World War I, that he would
more consciously manipulate reflected light
for artistic effect (see, for example, pl. 39).

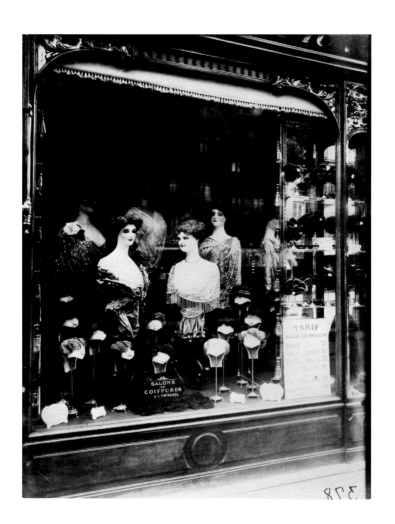

PLATE 26

Ragpicker's Hut

1912

Albumen print
22.9 × 17.5 cm
(9 × 6⅞ in.)
94.XM.108.6

Although Atget's subject matter, insofar as it concerns daily life in Paris, centers around the middle class, he did not ignore the poor, whether their appearance on the streets or the places where they lived and worked. Among the most poverty-stricken Parisians were the *chiffonniers* (ragpickers; see pl. 8), who combed the city for trash that might be collected and resold. (Recycled rags, for example, could be made into paper.) In Atget's time there were more than five thousand people involved in this form of trade, which was broken down into hierarchies according to the type of refuse that was amassed. Many of these fiercely independent individuals inhabited decrepit and decaying buildings, but others lived in gypsy wagons and ramshackle huts that they had assembled from their street findings. These flimsy shelters were to be found in outlying areas of Paris, set up on the ground where the metropolis's outmoded, mid-nineteenth-century defensive walls had been razed.

The structure that Atget photographed here was atypically picturesque, its poverty partially masked by the decorations of detritus affixed to its sides and roof and the vines growing from a crude window box up onto strings across the window opening. The discards reused as architectural embellishment include several woebegone dolls and a variety of stuffed animals, including a sheep and woolly dog. Despite the cheerful bravado of these adornments, close examination shows that the walls are burlap tacked over crude shingles and that heat was supplied by some sort of stove, evident from the crooked pipe that protrudes from the roof. Running water was certainly not available. The pair of worn boots left outside at one corner of the rude habitation is a poignant indication of the impoverished state of whoever lived there. It is remarkable that Atget was allowed to so closely infringe on a stranger's dwelling.

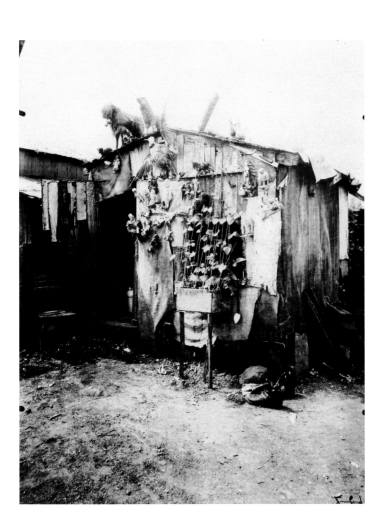

PLATE 27

Old Mill, Charenton

1915

Albumen print
18.1 × 21.6 cm
(7 ⅛ × 8 ½ in.)
90.XM.124.2

Of the several views that Atget made of this modest mill at Charenton, close to the point where the Marne joins the Seine, only this one makes it seem monumental. (Charenton is on the southeast outskirts of Paris, adjacent to the Bois de Vincennes.) Because of the camera's compression of planes, the various components of the image have been flattened into what seems to be a Cubist collage. It is hard to resolve these spatial elements visually, but underlying the composition is a formal geometry that is anything but Cubist. The principal bulk of the building vertically bisects the picture plane, while the springing arch of the wheel-less mill and the coping of the wall to the right horizontally halve the photograph, producing quadrants that are violated only by the strong diagonal of the grassy bank in the foreground.

Atget made very few views during World War I, as he was too traumatized by its disruptions and privations to have much appetite for work. The national institutions that were collectors of his pictures had suspended their purchases from him, and the bombardments of Paris caused him to safeguard his negatives by storing them in the basement of the building where he lived. This image of 1915 is one of the last he made before completely discontinuing photography during 1917 and 1918.

PLATE 28

Reflecting Pool, Saint-Cloud

1915–19

Albumen print
18.2 × 21.7 cm
(7 ³⁄₁₆ × 8 ⁹⁄₁₆ in.)
90.XM.64.51

From 1904 until the end of his life, but particularly during the 1920s, Atget often made photographs of the gardens at the site of the palace of Saint-Cloud, just outside Paris (see also pl. 18). They were designed by the great French landscape architect André Le Nôtre (1613–1700), the principal inventor of the classical "French garden." Most famous for the layout of the gardens at Versailles, which he devised for Louis XIV, Le Nôtre worked at Saint-Cloud for the king's brother, the duc d'Orléans. In both settings he used similar formal elements: reflecting pools, fountains, symmetrically placed urns and statuary, and massive blocks of clipped shrubbery bordering long axial vistas.

Among the devices that Le Nôtre employed is a kind of forced perspective, created by using progressively smaller blocks of greenery as the vista recedes from the viewer, thus giving the impression that the distance is greater than it actually is. An analogous effect is visible in Atget's photograph. (The illusion of distance is furthered by the fact that the ground falls away at the end of the prospect, where the château once stood.) As Le Nôtre also intended, the reflections in the pool emphasize the perspective. Atget has capitalized on these effects but infused the formal arrangement with dynamism by placing his camera away from the central axis and capturing the irregular shapes of the masses of unclipped vegetation. The statues that lead the procession into the distance, of Diana and Apollo, are now to be found in the Louvre.

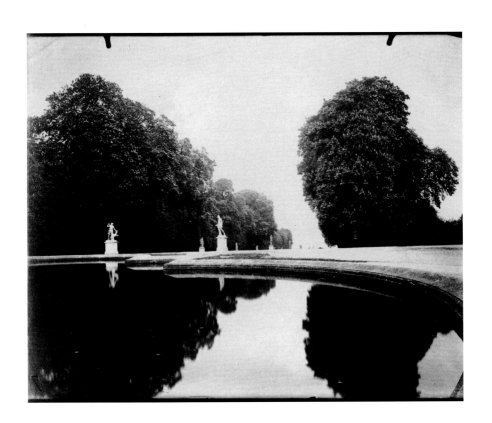

PLATE 29

Rue de l'Hôtel-de-Ville

1921

Albumen print
21.6 × 17.8 cm
(8 ½ × 7 in.)
84.XM.1034.7

On the left of Atget's view, a pepper-pot turret of the fifteenth-century Hôtel de Sens bellies out over a turn in the rue de l'Hôtel-de-Ville, which was first laid out in the thirteenth century roughly parallel to the Seine on the Right Bank. A more orthodox photographer might have moved on around the bend to capture the principal facades of the mansion, the oldest non-religious structure in Paris, but Atget was clearly interested in recording the narrow and crooked lineaments of the ancient street. Its appearance had last significantly changed when its old paving blocks were replaced with a smoother surface sometime after 1860. The pipe-smoking uniformed man who gazes toward the camera from the doorway of a hotel on the right (see detail on p. 142) perhaps understood Atget's

purpose or obeyed his specific request and moved into the recess in order that the foreground be unobstructed. As is consistently the case with Atget's street photographs, the view is one that a pedestrian moving into and through the space would see.

Atget's instinct that this street was a part of Paris that would change was correct. The exterior of the Hôtel de Sens is now much restored, and the wall that leads to it in this image has been taken down, revealing a garden and partially liberating the building from the urban matrix that held it. The long exposure required to obtain detail in the deeply shadowed street has caused overexposure in the upper, more brightly lit stories of the various structures, creating an hourglass of light elbowed by triangles of darkness.

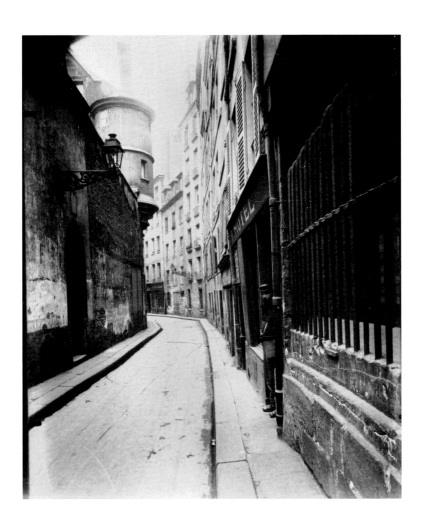

PLATE 30

Prostitute, Versailles

March 1921

Albumen print
21.7 × 16.4 cm
(8⁹⁄₁₆ × 6⁷⁄₁₆ in.)
85.XM.350.1

In 1921 the painter André Dignimont (1891–1965) commissioned Atget to make a series of photographs of prostitutes for a possible publication. About a dozen pictures resulted, taken between March and May. Some, like this one, were created in the town of Versailles, where this woman lingers in the doorway of a brothel, indicated by the size of the street number over the door. Prohibited from identifying their bordellos with signs, proprietors resorted to posting larger than ordinary numerals—some much more conspicuous than this example—so that customers could recognize the true nature of the establishments.

Despite her self-protectively crossed arms, the prostitute who poses in front of this scarred facade does not seem averse to being photographed. A friendly, if not particularly alluring, smile is fixed on her heavily made-up face, and clearly she wears her working costume. Her skirt is extremely short for the time, like those of some of the other prostitutes that Atget photographed. Its abbreviated length is intended to attract customers by displaying her legs. Similarly, her high-laced boots can be assumed to have a sexual connotation, which is perhaps somewhat at odds with her bright white socks. The fox fur that hangs limply from her shoulders presumably is meant to add a touch of class to her appearance. It would be interesting to know how Atget explained his objective to this woman and if he paid to photograph her. His even-handed treatment of her is parallel to his images of tradespeople (see pls. 7–8). Of all of Atget's pictures, only this series and three nudes, probably made in a brothel in 1925, deal with sexuality.

PLATE 31

Nymph with a Shell, Versailles

1921

Albumen print
21.5 × 18.1 cm
(8 7/16 × 7 1/8 in.)
90.XM.124.4

This statue of a nymph with a shell that Atget photographed in 1921 in the gardens of Versailles was a mediocre copy made by the sculptor Auguste Edmé Suchetet (1854–1932) in 1891 to replace an original that had been commissioned from Antoine Coysevox by Louis XIV in 1683. Suchetet also repaired the original, already once restored earlier in the century, and it was then moved to the Louvre. Coysevox's work was a free interpretation of an antique Greek statue in the Borghese Gardens in Rome, of which a cast had been sent to Paris.

The discoloration on the cheeks of Suchetet's copy makes the nymph appear to be weeping, increasing the poignancy of the forlorn figure, nearly naked against a background of leafless trees and wintry skies. By positioning his camera close to the statue, Atget achieves an image of greater intimacy than is usually the case with his photographs of sculpture. As earlier the piece by Coysevox had suffered the ill effects of weather, so also its replacement shows traces of wear. Thus the picture becomes a meditation on youth and age, on the inevitable decay of both flesh and stone, on time and the passage of the seasons.

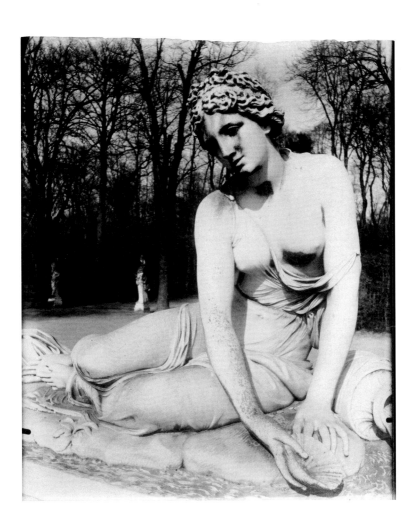

PLATE 32

Rue Cardinale

April 1922

Albumen print
17.9 × 21.9 cm
(7 1/16 × 8 5/8 in.)
90.XM.127.2

Atget repeatedly photographed this neighborhood and the tiny street that leads away from the intersection and then turns sharply to the left. The rue Cardinale is less than two hundred feet long and little more than sixteen feet wide at its narrowest point. It was named after the cardinal (Furstembourg) who was the prior of the Abbey of Saint-Germain-des-Prés when the street was laid out in 1700 on what had been a lawn tennis court on the abbey grounds. The site had changed very little from 1899, when Atget first photographed it. He may have been drawn to it as a durable record of a kind of imagined urban innocence.

The sharply angled lines of the dark buildings in the foreground lead the eye to the white house on the far corner of the irregularly shaped intersection. Atget carefully placed his camera so that the plane of the house terminates the near vista. Had he moved his camera slightly to the left, another street parallel to the rue Cardinale would have become visible, diluting his one-point perspective. The spatial qualities of the place are neatly captured. There is no one visible save for a ghostly figure with a ladder under a distant streetlight that resembles the one in the foreground. The scene is so pristine as to make this seem like a stage set just after the curtain rises. One waits for a figure to appear at the open window or for the little band of artists and writers in Puccini's *La Bohème* to come carousing around the corner at the beginning of act two.

PLATE 33

Pont Neuf

1923

Gelatin silver print
18 × 22.8 cm
(7 $^{1}/_{16}$ × 9 in.)
90.XM.64.18

Atget inscribed the back of this print *Pont Neuf,* identifying the venerable "new bridge" (completed in 1607) that is dimly visible in the background. More precisely descriptive of at least the foreground subject of the photograph, he wrote on another print *les Quais,* meaning the wharves along the Seine. On the second he also noted that the image was made in winter, which might be guessed by the low-lying fog that obscures the buildings across the river and swathes the distant bridge in a watery cloak. This mist was enhanced by a flaw in the processing of the present print, which created a cloudy band along the right margin.

Earlier in Atget's career he had systematically documented the embankments and quays along this section of the river as well as their attendant commerce, but here his interest lies more in mood. This shift from documentation to study of atmosphere reflects the change in his sensibility after World War I, a move from the prosaic to the poetic.

As if in a detective novel or espionage film, the two figures standing on the ramp that leads down onto the quay at the left seem to have staked out the barges below for surveillance. The gentle curves of the boats are echoed in the arc of the stonework to which they are tied. The feathery tree sharply contrasts with the spiky mast of the vessel nearest the dock. Except for the luminous glow in the sky and the white trim on the barges, the photograph is uncharacteristically dark, mysterious, and faintly ominous. Paris in winter is eerily evoked.

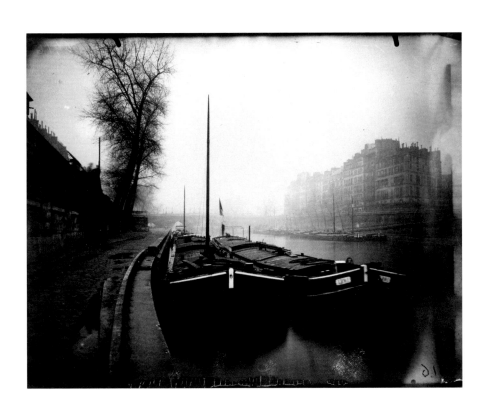

PLATE 34

Old Convent, avenue de l'Observatoire

1923

Albumen print
22 × 18.2 cm
(8 ¹¹/₁₆ × 7 ³/₁₆ in.)
90.XM.127.1

Atget's inscription on the back of this image indicates that this building was once a convent and was located on the avenue that leads from the old observatory to the Luxembourg Gardens. More precise identification of it seems impossible, as the area once had several convents. From the elaborate treatment given to the chimney on the left end, the establishment was evidently well endowed. In Atget's photograph the structure seems nearly abandoned, its melancholy heightened by the bare branches of the trees. However, an open dormer window suggests that the place was still in use for some purpose.

With the high, weather-stained wall separating the viewer from the brooding building, and the ladder leaning against the streetlight, the picture suggests an episode in a novel, maybe one in which a nun is abducted. This invests the image with a romance that its maker may not have intended but is perhaps a forgivable sin of interpretation with a photograph as atmospheric as this one. In the 1920s a sale of a large body of Atget's work had made him financially secure, and his views of this period were made more to please himself than had been the case in earlier years, when he concentrated on making simple documents for sale. His work became more concerned with the effects of weather, season, and mood.

Although this print once belonged to Maurice Utrillo (1883–1955), who occasionally used Atget's images as direct sources for his paintings (see pls. 40–41 and pp. 112–13), there is no known work that is modeled on this photograph.

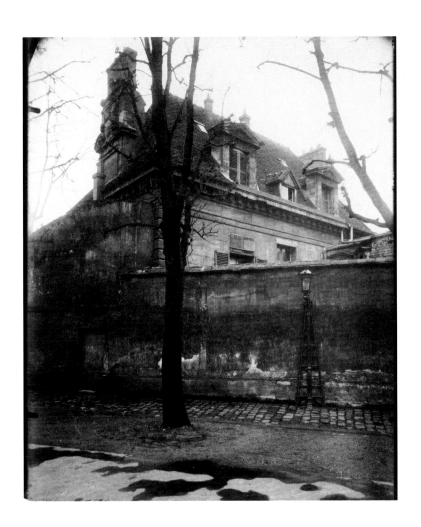

PLATE 35

Staircase,
Montmartre
1924

Albumen print
21.8 × 17.8 cm
(8 ⁹⁄₁₆ × 7 in.)
90.XM.124.1

This tautly composed image of a precipi-
tously raked staircase descending the
hill of Montmartre is another example of
the kind of personal photographs that
Atget created in the 1920s. He placed his
camera at the top of the stairs, which
are flanked by a ramp too steep for vehi-
cular traffic. The staircase and ramp are
jointly named the rue du Calvaire, not
because they are a penance to climb, but
because this area is associated with events
connected to the martyrdom nearby in
Roman times of Saint Denis, patron saint of
France and alleged first bishop of Paris.
As the stairway was not constructed until
1844, Atget's interest in the site was prob-
ably motivated less by its historical associa-
tions and more for its picturesque qualities,

emblematic of the kind of spaces that in-
creased urbanization was obliterating.

The photograph is a study in the
contrasting textures of decaying plaster, cor-
roded metal, and battered stone. The leaf-
less tree, which perfectly fills its square of
sky, is an emphatic vertical, steadying
the downward rush of stairs. Perhaps even
older than the tree, and next to it in the
patch of hillside garden squeezed among the
houses, is a classical herm, a domestic
sculpture that ameliorates its surrounding
banality. Chimney pots and stacks create a
staccato fringe along the rooftops in this
densely packed and melancholy composition.

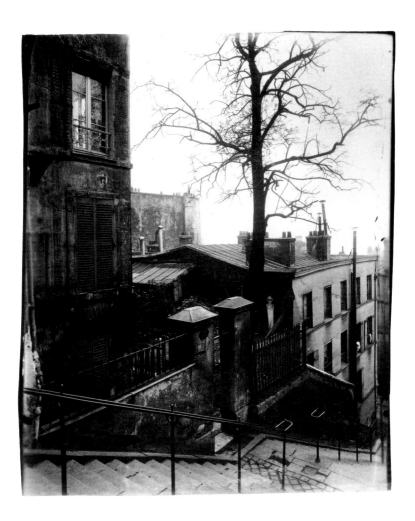

PLATE 36

Panthéon

1924

Gelatin silver print
17.8 × 22.6 cm
(7 × 8⅞ in.)
90.XM.64.34

Atget is usually thought of as depicting or-
dinary streets and buildings that preserved
modest aspects of Paris's past, but he
also made views of the city's great public
monuments. Nearly all of these images
are of structures built by the Bourbon mon-
archy, which was overthrown by the French
Revolution. One of the principal and final
glories of royal patronage is the Panthéon,
the Late Baroque masterpiece by the archi-
tect Jacques-Germain Soufflot (1713–80).
Intended by Louis XV to be dedicated to the
patron saint of Paris, Geneviève, this
cruciform, domed church was constructed
between 1755 and 1792 on the top of the
hill on the Left Bank named after the saint.
It acquired its present name and function
during the Revolution, when it was converted
into a mausoleum for the remains of great
Frenchmen. Among those interred in its som-
ber splendor are Voltaire, Rousseau, Marat,
Hugo, and Zola.

Atget made his atmospheric study by
photographing diagonally across the place
Sainte-Geneviève toward the north side of
the Panthéon, with its powerful colonnaded
dome. Because the negative is printed very
darkly, the church of Saint-Étienne-du-
Mont in the left foreground becomes a black
silhouette balanced by the dark mass of
the building on the right. Together they frame
the Panthéon, which is rendered entirely
in muted grays. The photograph becomes as
much a study of Paris weather as of Paris
architecture. The sharply raked lines of
the foreground buildings and the pattern of
the wet paving stones lead the eye into
the misty distance, while the procession of
diminishing streetlights emphasizes the
bulk of the Panthéon, looming beyond. Atget
has cannily marshaled an array of pictorial
and procedural devices to produce a highly
dramatic image.

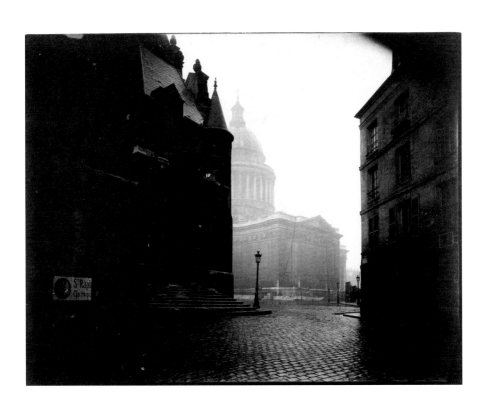

PLATE 37

Corner of the
rue de Seine and the
rue de l'Échaudé

May 1924

Gelatin silver print
22.7 × 17.9 cm
(8 $^{15}/_{16}$ × 7 $^{1}/_{16}$ in.)
90.XM.64.7

Atget's photograph of this spiky, angular building at the junction of two streets on the Left Bank is strikingly like a set for a German Expressionist film, such as *Nosferatu* (1922). One nearly expects to see a caped vampire fleeing the dawn. However, a large part of this effect is due to the exceptionally dark printing of the negative, which makes the streets appear as if they are still enveloped by the night. Other prints of this image are far lighter and less dramatic.

The neighborhood in which this intersection exists is one in which Atget consistently photographed. He made pictures of this wedge-shaped building in 1904, 1911, and 1924. The convergence of the streets posed for him the problem of balancing their perspective and the volume of the structure, as David Harris has pointed out. Sometimes Atget moved a little closer, sometimes a little to one side, but always so as to show the edifice's odd shape. This and its anonymity of style attracted his attention, although the building is devoid of specific historical importance. Its form was dictated by the site, the footprint of which was a result of the earlier history of this part of Paris. The rue de l'Échaudé, on the right, had been built along the line of a deep ditch that ran in front of and parallel to the fourteenth-century fortified walls of the Abbey of Saint-Germain-des-Prés, which then lay outside the walls of the city. The rue de Seine, on the left, was built along a prolongation of a line that followed the city's fortifications. The structure itself still exists, although the present lineaments are uniformly bland, more like their state in 1904 than in 1924.

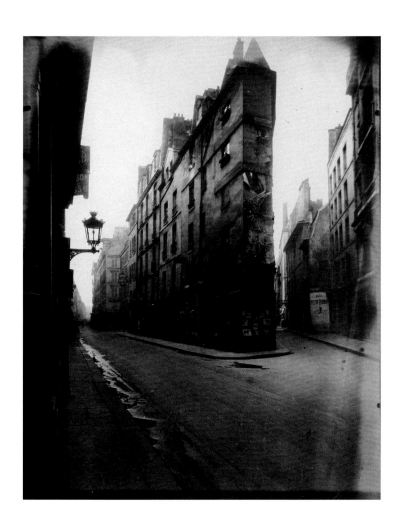

PLATE 38

L'Hôtel de Royaumont, rue du Jour

1925

Gelatin silver print
22.6 × 17.9 cm
(8⅞ × 7 1/16 in.)
84.XM.1034.10

The Paris dwellings of the rich were traditionally shaped around a forecourt, with the principal rooms located in the block farthest from the street. Such was the case with the building in the foreground of this photograph, the Hôtel de Royaumont, which was constructed in 1612 for a high-ranking French churchman. It stood immediately next to and in the shadow of the large and important church of Saint-Eustache, which was still under construction when the house was built. Rented for years to secular tenants, the mansion was confiscated by the state after the French Revolution. By 1860 it was occupied by a crockery and porcelain merchant, whose wares were advertised by signs painted on the exterior walls. The arch of the entrance gateway was covered by more signage, and the noble edifice was in decrepit condition. The building now on this site has the same volumes as the ancient residence and similar details but was constructed in 1950; hence its present appearance is pristine by comparison with the structure in 1925.

Atget rarely made a grittier photograph than this, which is highly expressive of urban density and decay. The short focal length of his lens produced a compression of the architecture of the manse and church, so it is difficult to separate the uniformly grime-coated elements of each building. The shadowy little girl in the doorway, who moved away in the course of the exposure, seems nearly as dirty as the stone. One wonders if her life was as deprived as the setting would suggest. The tilted barrow and the litter in the street add further forlorn notes to a depressing scene of squalor, in which even the letters of the truncated sign at left, although the brightest tones in the photograph, become ominous.

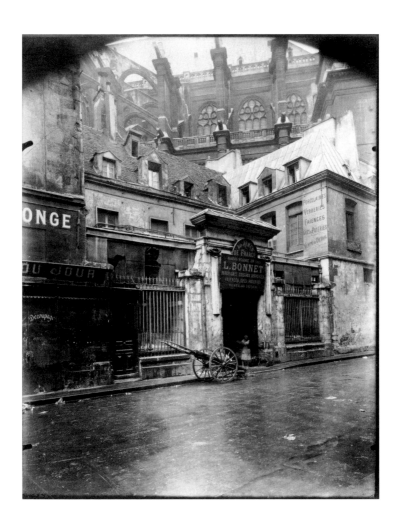

PLATE 39

Storefront,
avenue des Gobelins

1925

Matte albumen print

23 × 16.8 cm

(9 ¹⁄₁₆ × 6 ⅝ in.)

84.XM.1034.15

Atget's vibrant study of this display of
women's apparel, a tableau of a stylish, if
frozen and partnerless, minuet being
danced on the other side of a row of tightly
furled umbrellas, is one of a series of at
least four pictures that he made of the same
clothing store. He moved his camera along
the sidewalk so as to show each of the
establishment's display windows. This one
exhibited garments for women; another,
clothing for men; and a third, attire for
children. The dramatic quality of this image
derives from the exaggerated poses of the
mannequins and the reflected silhouettes
of the trees and the domed structure across
the avenue des Gobelins. (The building is
the museum of the Gobelins tapestry works.)
This avenue still has emporia devoted to
the sale of clothes.

The calculated interplay between
what is seen through and reflected by the
glass distinguishes Atget's later views
of storefronts. Reflections in his earlier
studies of shop windows were less precisely
thought out (see, for example, pl. 25),
but by the time this picture was produced,
Atget's long experience as a photographer
had made him fully conscious of what his
finished plate would show. The juxtaposi-
tions created by the mixture of internal and
external elements transform the ordinary
into the unexpected, a quality prized by the
Surrealist artists, who discovered Atget's
work at about this time.

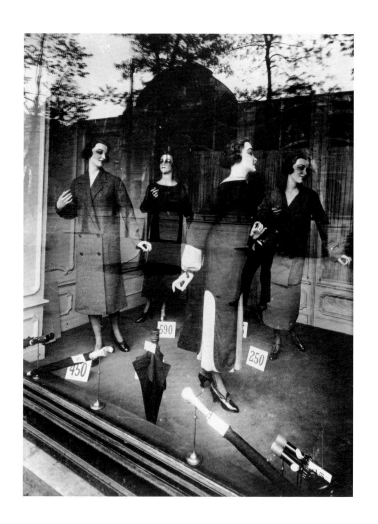

PLATE 40

L'Hôtel Scipion
Sardini, rue Scipion

March 1925

Matte albumen print
17.8 × 22.3 cm
(7 × 8¾ in.)
86.XM.23

Scipion Sardini (died 1609), who built this elaborate house and its appendages in 1565, was an Italian who came to France in 1553 in the wake of Catherine de Medici, the Italian heiress who married King Henri II. As a tax collector and banker to royalty and the nobility, Sardini became rich, unpopular, and then very rich. His mansion was the first of many buildings to be constructed in Paris in a mixture of stone and brick, the stone being used to mark corners and surround windows and doors, and the brick as a wall surface. After Sardini's death the house was used as a hospital for the poor; then, during an outbreak of the plague, as a temporary prison; and later as the central dispensary for candles, meat, and bread for all the hospitals of Paris. Today it continues to be the place where bread for the hospitals is baked.

Of the several views that Atget made of this building, this one, taken from the square that borders a side of the mansion, shows the aspect of the exterior that had least changed from the time the house was constructed. The dim light of winter produced a range of gray tones on the brick and stone surfaces that is offset by the black of the foreground trees and the white of the snow that catches the sunlight.

This print, according to an inscription on the back, belonged to Maurice Utrillo, who is known for his views of Paris, particularly of Montmartre. He directly modeled a 1926 painting on the photograph (see p. 112), altering nothing in Atget's composition except for changing the season to what seems to be spring, adding several figures, and brushing in a few spindly shrubs in the foreground.

PLATE 41

Kiosk and Street Fair, Fête de Vaugirard

1925

Gelatin silver print
17.9 × 22.6 cm
(7 ⅟₁₆ × 8⅞ in.)
90.XM.64.39

Among the aspects of Parisian life that Atget thought were endangered and wished to record before they disappeared were the seasonal street fairs that occurred in various neighborhoods in the city. Consistent attractions at these carnivals were merry-go-rounds and circuses with menageries and collections of sideshow freaks. His principal subject in this study is a tawdry, painted pavilion that housed an assortment of animals and, behind it, the "modern" Cirque Lambert. Dangling from the porches of both establishments are primitive electric light fixtures that provided nighttime illumination. There is a somewhat puzzling absence of carnival shills and fairgoers in the picture, but litter on the pavement attests to their earlier presence. In 1922 and 1924–27 Atget made other images of this festival, which was held annually in the area of Vaugirard, near Montparnasse.

Engulfed by the temporary structures of the fête is a domed hexagonal kiosk that was a permanent fixture of the street. It carries advertisements for newspapers, soup, chocolate, winter vacations in Monte Carlo, etc. A more significant indication of the ordinary appearance of the quarter is the multistoried apartment house visible at left behind the shed and trees.

Maurice Utrillo owned a print of this image and used it as the direct source for a painting in 1927 (see p. 113). To Atget's composition he added only an imaginary poster on the wall of the shed and several groups of figures to animate the spaces, as if the fair were in fuller operation.

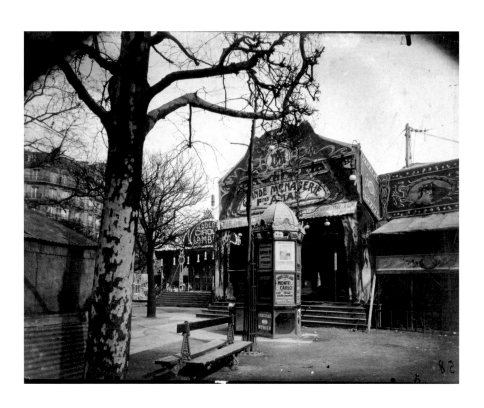

PLATE 42

Sideshow Attraction,
Fête du Trône

Circa 1954 gelatin silver print
by Berenice Abbott
from a 1925 negative
17.3 × 22.5 cm
(6¹³⁄₁₆ × 8⅞ in.)
90.XM.64.14

Of the many pictures that Atget made of
the seasonal street fairs of Paris, this is
his most famous. At first it seems to be of a
mysterious assemblage composed of dis-
parate elements floating in a void of black-
ness, but upon examination the components
gradually resolve themselves into related
pairs, and the secret is revealed. The objects
form an advertisement for a sideshow
attraction comprised of a giant and a midget.
A shoe for each sits next to a chair for each;
suspended overhead are photographs of
the two together (see detail on p. 132). Plac-
ards on either side state that the price of
admission is one franc. At the apex of the
pyramid a single bare light bulb adds a
stark, utilitarian note that perhaps bespeaks
a threadbare advertising budget. As a three-
dimensional promotion, the stacked furni-
ture was serviceably (and adroitly) placed
behind a barrier that blocked the entrance
to the attraction when it was not open.

Other views that Atget made alongside this
display show adjacent painted panels that
present the larger man in situations made
comic by his stature. If the panels are to be
believed, Armand the Giant was seven feet
ten inches tall and his companion was "the
smallest man in the world."

The apparent incongruity of elements
makes this seem a Surrealist image,
and it was just these bizarre and unexpected
components that drew Marcel Duchamp,
Man Ray, and Berenice Abbott to Atget's
work. Their adoption and publication of his
pictures shortly before his death may have
puzzled the old man, whose intent was
simply, he insisted to them, documentary.
Inadvertently his photographs became
not the raw material for the creations of
artists but supports for an artistic aesthetic.
Abbott would champion and preserve
Atget's prints and negatives after his death,
making possible his present reputation.

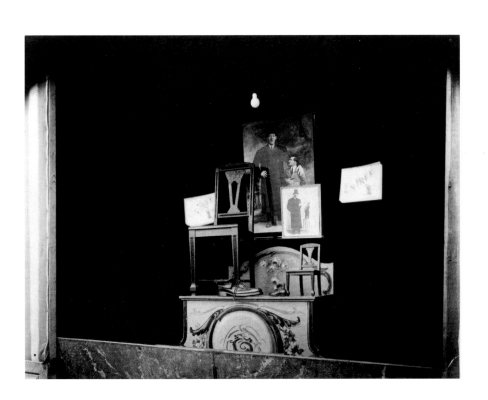

PLATE 43

Place Pigalle

1925

Gelatin silver print
17.8 × 22.9 cm
(7 × 9 in.)
90.XM.64.171

The place Pigalle and its surroundings in Montmartre have been a center for bawdy nightlife from at least the 1870s, when artists and writers frequented its cafés and music halls, until the present, when tourists flock to its strip joints, drag shows, and discotheques. Despite this colorful history, Atget seems not to have photographed the place Pigalle until 1925, when he made at least three views of the buildings that line it. With his back to a fountain in the center of the semicircular space, he made his study of this newly remodeled structure. It had earlier housed a cabaret, patronized by Toulouse-Lautrec and Zola, with a roof garden, which was later enclosed to house a supper club, the New Monico. (An earlier Monico occupied the premises in 1910.)

Below the club is a restaurant, its tables and chairs ready for the day's clients. The trash cans neatly lined up along the sidewalk indicate that the image was made very early in the morning. Above and behind the rooftop sign for the club is a large attic window that perhaps lights a painter's studio. In addition to the stylish Art Deco embellishments to the facade, further traces of modernity are the automobiles, rarities in Atget's pictures, that are parked in the street that veers to the right. There too is a horse-drawn cart, the driver of which is presumably making a delivery. Appropriately for a district famed for nightlife, the moon presides over the scene, but only from a giant billboard that advertises pasta.

PLATE 44

The Marne
at La Varenne
1926

Gelatin silver print
17.9 × 22.7 cm
(7 1/16 × 8 15/16 in.)
88.XM.20.2

The banks of the Marne near Paris were a
subject for Atget in 1903, again between
1919 and 1921, and finally toward the
end of his life, in 1925 and 1926. The river
is a slightly surprising choice of subject
matter for him, as it is pastoral, lacking the
evidentiary data of his studies of urban
architecture, commerce, trades, events, and
street scenes. As few of his riverine pictures
include people, it is not traditional popu-
lar pastimes he records here, but places
where they occurred. As such, these views
are most closely connected to his studies
of street fairs without their customers and
images of empty royal parks, although
lacking the grander historical associations
of the latter. If he intended these photo-
graphs as documents for artists, it is unclear
exactly how he thought they might be used,

but what is sure is that in the mid-1920s he
was drawn to landscape and atmosphere, a
more personal than documentary vision.

The arcs of the bridge and its reflection
in the river are echoed by the more grace-
ful curves of the skiffs and rowboats that
nestle against each other while waiting
to be rented. This idyllic part of the river,
a short excursion by train from the city,
was a favorite weekend retreat for Parisians,
who were drawn to it for its riverside
cafés and restaurants and for fishing and
boating. But now the oars and fishing gear
have been stowed, water has been wrung
out from hems, the remnants of lunch
have been bundled into picnic baskets, and
departures for the city have been made.
A misty reverie obtains.

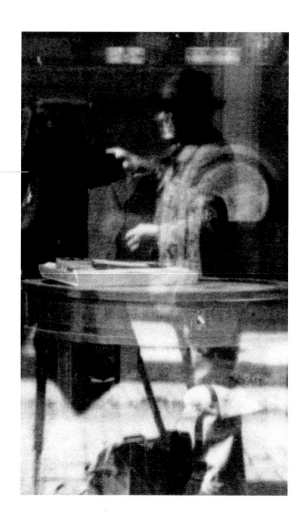

Eugène Atget.
Antique Store, rue du Faubourg-Saint-Honoré, 1902
(pl. 12, detail).

Documents for Artists:
The Photographs of Eugène Atget

David Featherstone: During our conversation today about Eugène Atget, we're going to be looking at a series of his photographs, some singly and others in pairs. I hope you will share your thoughts about the images, subject matter, or events both within and beyond Atget's life that informed the picture-making choices he made. To begin, I'd like to ask Françoise Reynaud to give us a brief biographical sketch of Atget.

Françoise Reynaud: After many years of studying Atget, he is, for me, still a mysterious person, and it is not always easy to describe him. He was born in 1857 in Libourne, a small town in southwest France, not far from Bordeaux. His grandparents raised him after his parents died. He evidently worked as a sailor, but nobody knows exactly where and how.

He came to Paris quite early, in 1878, to study theater. He became an actor and worked until 1887, when he abandoned the profession and became a photographer. He never lost his interest in the theater, though; he later taught evening classes on its history. The companion of his life, Valentine Compagnon, whom he met in 1886, was an actress who traveled many years performing everywhere in France.

Atget became a photographer outside of Paris, in the department of Somme, where he lived for a while. He moved back to Paris in 1890 and never left after that. He started by making images of rural scenes and selling them to artists, who used them as documents from which to paint. Just before 1900, he began selling photographs to libraries, museums, and archives as well. That's how his life's work of

making pictures of the streets, of people in the streets, and of the traditional life and art of the city started. Until his death, he never stopped photographing, except perhaps during World War I. His career developed more and more systematically as a commercial photographer, and although you could not have bought his photos in any shop, he really supported himself through sales to people and institutions.

Despite this success, he was not well known in his time. Only archivists, amateur artists, and craftsmen were familiar with him. He wasn't known in the world of trendy artists, except by the Surrealists. Man Ray lived on Atget's street and had bought images from him, but even so, it was very late in his life that serious artists began to recognize him and appreciate his photographs. He died in 1927.

Just before his death, Berenice Abbott, Man Ray's assistant and student, got to know him, and after she decided to go back to New York in 1929, his work became known here in the United States, mainly through her efforts. In France, however, it took a long time before exhibitions and books on Atget were produced.

Weston Naef: I've always been fascinated by the very curious turning point at which Atget falls in the history of photography. He was born when Roger Fenton was at the height of his creative powers and a full generation before Man Ray, who, as one of the people who befriended him, was perhaps the first really outspoken admirer of his work. When Atget was at the beginning of his career in photography, Robert Demachy and Constant Puyo were the most famous photographers in Paris. That was also when Alfred Stieglitz, the best-known photographer in the United States, was at a great turning point in his life and was about to abandon working in a documentary style. So Atget began his career working against the stream of photography as art. Those people who thought of themselves as artists were making photographs that resembled etchings, engravings, and drawings. He occupies an against-the-grain position that is often admired in artists.

DF: Thank you both. That gives us a good place to start. The first two pictures we'll consider, from 1901 and 1902, respectively, are *Shop Front, rue Michel-le-Comte* (pl. 6) and *Antique Store, rue du Faubourg-Saint-Honoré* (pl. 12).

Gordon Baldwin: I believe both of these studies of storefronts are self-portraits. *Shop Front* (p. 99) may be his initial attempt to make one. It's not as successful as

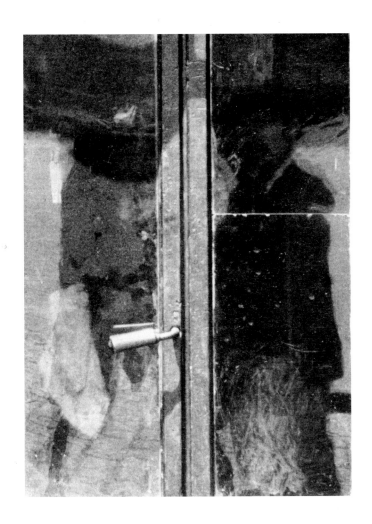

Eugène Atget.
Shop Front, rue Michel-le-Comte, 1901
(pl. 6, detail).

the self-portrait in *Antique Store* (p. 96), where he had a large plate of glass with which to work. I would argue that the figure in *Shop Front* is Atget because the height of the door handle in the center gives you an idea of the scale of the door. If the person in the glass were inside, he would be taller. So I think this must be a reflection of someone in the street, and that the camera is next to him. Perhaps after he looked at this photograph, he decided to make a real self-portrait, and he accomplished the other image the following year when he found a bigger and better window.

WN: I'm in accord with Gordon, for the following reason. The window is so dark and dirty that you can barely see through it. And if you could see through it, the interior of the room in which the man would be standing is also dark. It seems to me that if you just consider the circumstantial evidence, this couldn't be a person seen through the window. Plus, if you look at the image carefully, you can see the leg of the tripod and the camera.

Robbert Flick: The way he has set up his camera here is tricky. He has raised the front standard a little bit, so the camera is a little too high for the way you would actually see it face-on. In addition, he has angled the camera and created a little bit of space on the left-hand side that creates the depth, but it reads like a flat space. This happens frequently in Atget's work when he places the camera to create some sort of tension. I think he has positioned himself quite willfully. He is standing right next to the camera; it's the moment of exposure. But I think the impetus for the moment of exposure has to do with the well symbol and the way in which the image is constructed. This was not necessarily an intentional self-portrait.

GB: An accidental one perhaps, but it may have given him the idea to produce one.

David Harris: I think *Antique Store* is the only picture of his that I would say is clearly a self-portrait. It's not a psychological one, but a portrait of his activity as a professional photographer working in the streets of Paris. Unlike *Shop Front*, in which the main subject is the decorative ironwork above the door and the portrait is inadvertent in it, in this picture he has clearly positioned himself so that he would appear in the center of the glass in profile. If he had wanted to hide himself, he could have easily done so, either behind the camera or the window mullion. This is a portrait of a working photographer that reveals the conditions under which he

worked. He transported his equipment by hand to wherever the site was, set up his camera to take the picture, and then dismantled his equipment and moved on to another site. *Antique Store* is also a very interesting image because of the nature of the reflections. When you look at the window, you see both the interior of the shop and the opposite side of the street; the interior-exterior elements become intermingled in an extremely complicated way.

Michael S. Roth: The other obvious dimension of this self-portrait is the choice of the store, not only the window. It's hard to ignore the contents of the store when you think about Atget's working practice as a cultivator of things that may have been about to become antiques, that might soon acquire more value or at least more emotional and aesthetic investment because of their age.

This raises an issue that gets back to what Weston was talking about when he described Atget's position historically. One of the great and wonderful problems with Atget's work is its relation to what we call art. The notion of the intention of the artist in calling what he or she produces "art" is a problem in Atget's case, because he seemed to have such a different notion of his work than did the people who later appropriated him or read him as an artist. When we're dealing with a photographer who took thousands of images, how we classify his great pictures in relation to his intention as an artist, to his fortune, or to his misreading by successive generations is a recurring question.

Atget was at a turning point in how people were thinking about art in the late nineteenth and early twentieth century. When the Surrealists made use of him, his intentions didn't matter so much to them, because they had a very different notion of art than did those doing the aesthetic photography around him at the time. And Atget probably would have rejected that notion.

WN: *Antique Store* has always fascinated me in two respects. First, if you accept the proposal that it is a deliberate self-portrait and not an accidental one, then you begin to deal with the issues of expression and interpretation and ego. Every self-portrait that I know of is motivated by the desire of the artist to illuminate himself in some important way. Here we have anti-illumination. Second, not only is he barely visible, where he placed the camera is curious. He positioned it at such a point where the peak of the architectural element is violated. Moreover, the foreground

is trapezoidal, which means that the camera was not square with his subject. If you look carefully at the picture from this formalistic perspective, you get the signal that he was a little careless in placing the camera. He didn't put it perfectly plumb and didn't check in the viewfinder to ensure that the integrity of the building would be maintained.

RF: Maybe more important is the comparison to an architectural drawing rather than to an architectural photograph. Because if the information that he is trying to convey is what the architecture is, certainly in an architectural drawing everything would be plumb. But in the kind of photograph I think he was trying to make, it is less important. There are a lot of verticals that are slightly askew, but I don't think it's something that concerned him as long as he had the frontality to ensure correct proportions between the various parts of the facade.

WN: By 1900 the profession of architectural photography had been well established. You became an apprentice and learned how to make pictures in a way that satisfied your clients.

RF: Is he photographing an architectural thing or the frame of a building? I think what he's framing is the set, and he happens to be in there and makes use of that. I think he's really quite careful about not including that top line. His reference has to do with him standing in the street, looking at that place and looking for specifics.

DH: He's not making a conventional architectural photograph of a building, but rather one of this particular type of commercial facade and its decoration. And he's making it with a sense of how you would perceive this structure from a pedestrian's point of view. With most architectural photographs, the photographer would normally choose an ideal position, usually slightly elevated so as to remove the building from its immediate urban context.

FR: In our collection, these two images are catalogued as documents about street signs. Around 1900, many books were published about the old street signs of Paris. The images were usually engraved or drawn—not so many photographs existed in publication—but these signs were documented. These photos are in our topography files according to their addresses; that's how they were placed when Atget sold them

to us. *Shop Front* is a street sign of a place where you drink wine, as you can see by the bottles in the window. In our collection, we have engravings and drawings of the same place by other artists in other periods, from the middle of the nineteenth century until the beginning of the twentieth. For me, these images are not architectural, but more decorative. As Robbert said, Atget usually would not be exactly in front of his subject, but a little to the side so that the structure is part of a larger scene.

RF: I'm particularly fascinated by the bars in the windows here. They are close together so that you can't break the glass to get to the bottles. I continually find in Atget's photographs that by including additional layers of information about the context of place, he provides information that probably isn't even visible to him. He plays with a subject as an encounter with place, and in doing so he provides both a future and a past almost simultaneously.

FR: I don't agree really with the idea that this is Atget here. When he took photos in the little shops, there very often were people looking at him. The other photo looks like a very thought-out self-portrait, but it's discreet. Although he's in the middle, he's not the main theme of the photo. His main purpose is to photograph art and architecture, but he was not an architectural photographer himself. When you compare his photos with those of Charles Marville and Édouard Baldus, which are forty to fifty years earlier, there's a big difference between these photographers of architecture and Atget, who is more between decorative art and architecture.

MR: Being slightly askew gives a feeling of movement. As David was saying, you have the point of view of a pedestrian, of someone moving in the street. People are usually not standing in the street, they're moving. I have the sense from the angle that you're moving past these things; you don't have time to dwell on them in the city.

WN: We can try to deduce from these two pictures a little about what Atget's working methods were like. In the antique shop facade we see that he is perfectly alone. He doesn't appear to have an assistant. He seems to have carried his equipment to the site in the satchel that sits at his feet. Where I'm headed with this is to describe a man of very simple needs. He doesn't have what we would think of today as a designer photographic case; this is a satchel. He is making do with the minimum

that he needs to do his work. I'd like to use that as a measure for the temperament of this man. From all that we know of him from Berenice Abbott and Man Ray and Ferdinand Reyher and other people who have looked carefully at what he was like at the end of his life, twenty-five years after this picture was made, he still seemed to be a person of very simple means who lived in a modest apartment, ate the simplest possible food, and dressed in the same clothes nearly every day. He was a person who lived for his art, or lived with his job.

GB: There were so many books in his apartment, it seems that he was also a voracious reader, so there was something apart from his job to indicate that he had wide-ranging cultural interests. He had political interests too, as we know by his donation of socialist periodicals to Paris institutions in the early teens.

DF: The next photograph shows a group of children playing in the Luxembourg Gardens in Paris (pl. 1). Although its date of about 1898 places it just three years earlier than the images we just looked at, it seems very different.

GB: This is a very different kind of scene. The nursemaid, who's dressed up against the cold, is suspicious of what this man is doing photographing her and her charge, whom I take to be the little girl on the right. The boy on the left, aware of what Atget is doing, has hesitated momentarily to look, while the other girl who is standing watches in puzzlement. All these individuals, even those in the background, are clearly interacting with the camera. This is quite a lot of people for an Atget photograph.

FR: This is one of the first acquisitions the Musée Carnavalet made from Atget, in 1898 or 1899. In our cataloging files, pictures like this were called *scenes de rue,* street scenes. For me, this is really a typical *scene de rue,* but of a park. It's a picturesque scene that shows the way of life of wealthy people, and that's part of traditional life in Paris as well.

WN: Maybe we should return to Atget's biography and recall what Françoise said in her introduction. At the time he took up photography, he had been an actor for approximately ten years. He was not a leading man; he played peripheral roles. I find it fascinating that this picture is all about peripheral characters. If one wanted

to pursue the idea that what defines a great artist is a quality of every image being autobiographical, I think that, once again, this picture is a kind of self-portrait. Atget is looking at the world in a very particular way. He could be seeing that boy in motion in the background as himself, as the person who is in motion on stage but does not speak. He is ignoring, for all intents and purposes, the central character, even though she's dominant.

MR: I can't disagree more. You raise a really important issue, which is that of reading Atget like one would read lots of other artists—a romantic way in which their art is fundamentally an exploration of themselves. But Atget seems to run so much against that, although he may at times implicate himself in his work. He is more concerned with finding the positions through which people see the things around them, especially things that may be of exceptional fragility, about to disappear.

DH: I would agree with Michael and not read this as primarily an autobiographical picture or one stemming from a psychological need. What interests me is the tension between the subject matter of this transient event, a subject matter that Atget will not pursue, and the space itself, which is something that he will pursue. In making the photograph, he had to set up a heavy, bulky camera that everybody would have seen, and he set it up in a place where I expect he realized this type of action was going to occur. In no sense is this a stolen image. But if you remove the figures, what remains is the space of the park itself carved out by the statue and the trees, with the allée in the distance. I see this image as foreshadowing what will become his principal preoccupation. At this period, he's making a picture his camera isn't ideally suited for and that his sensibility was not primarily engaged with.

RF: I tend to agree with Michael and David here. This is a picture that anticipates the spaces he'll photograph later on. What he is encountering here is the sense of time. And with the movement, it's a very limited, fragmented time. What is taking place is a slice of life.

What is going on in this image is the relationship between the woman and the statue. When you look at later pictures, the spaces in front of the statues are basically the containers of the future narratives, so I think this early photograph anticipates the kind of narrative structures that are going to appear in Atget's pic-

tures. But it sets an empathic mode in operation, which I suspect is where this biographical imposition that Weston was talking about takes place. It is directly related to the way in which Atget creates photographic narratives—a place seen, imbued with histories.

GB: If this is narrative, I think one would like it to be predictive. If the authority figure of one of the queens of France on her pedestal is echoed by the authority figure of the nurse in the center, then one would like the little girl on the right to grow up to be some kind of authority figure herself.

WN: The relationship between the statue, the woman, and the child is very powerful formally, but it is not one that you come to immediately.

DH: I also think, as Robbert was saying, that this was a learning picture. Atget was working through making photographs to finally discover what his subjects would be. Perhaps he had to take this kind of picture to reach that understanding. In later works, such as the first two images we discussed, when he went to a site, he had already identified what the subject was. Here I have the feeling that he set up his camera and waited. What he could control was the framing of the space itself, but he was waiting for a moment or event that was going to occur. That's what was unpredictable. The wonderful beauty of the picture is the moment that he was privileged to have.

DF: There's a theatrical aspect to what you're saying that seems relevant, considering the career transition he was making. It's as if he went to the park to establish a proscenium and then waited for this tableau to take place that he could photograph.

MR: Let me suggest something. We are talking about this as if what Atget was waiting for is what's in the picture. I keep thinking about the allée in the background, which is empty. Was he waiting for the whole scene to be empty? We're all assuming that he's waiting to get a good shot of the children, but my eye keeps going to the center of the picture and a perhaps typically nostalgic Atget and the pathos of an empty kind of space. It may be that what we're paying attention to is not what Atget was looking for, which was an empty Luxembourg Gardens.

FR: This picture is about the park, but it's also about the profession of the woman, the governess. This is a crossover image between the portraits of *les petits métiers*— the street tradespeople—and the scenes of the parks and streets. There is a clear relationship between this figure and the photographer.

WN: Atget is sometimes the most intuitive and impulsive of all photographers, but in the *petits métiers,* suddenly there is another side of this man that seems to be more deliberate and disciplined. As we look at the pictures today, think about this dichotomy between the impulsive and the intuitive on the one hand and the deliberate and planned on the other hand. Is this intuitive or planned?

GB: I think David has argued, rather successfully, that it's intuitive. Atget put his camera into place and waited for the scene to happen. If the scene wasn't there when he started out, it couldn't be planned.

DF: This is a good opportunity to move to the portrait of the lampshade vendor (pl. 7), which is dated 1901.

GB: The lampshade vendor had a rather peculiar job. What is the likelihood that the lampshades he is selling will fit the decor of someone's house? I suspect that this was a very marginal profession.

DH: What has always intrigued me about this picture is that it is unlike all the other images in the *petits métiers* series. They are usually made with a very shallow depth of field so that the figure appears almost like a statue and the background is out of focus. In this picture Atget has used a wide-angle lens with the lens stopped down, resulting in a very long depth of field. Everything from the cobblestones in the immediate foreground to the distant background is rendered in focus. Unlike the images where the picture's focus is on the person and the background becomes peripheral, this one is equally about the space of the street and the lampshade seller. The fact that it's all in focus gives the image its strange spatial quality. You're not quite certain what the man's physical relationship is to the space.

FR: This photo was taken in Montmartre. It is one of the few pictures that Atget took of *petits métiers* outside the center of Paris.

GB: The street is so empty that one wonders where his customers are going to come from.

FR: You can see some people—moving shadows—on the sidewalk; the length of the exposure makes the street appear empty.

RF: This links beautifully with the previous picture, because there is a similar sense of movement and the stretching of time.

MR: One of the things I think is really interesting about the *petits métiers* series is the concentration on an aspect of Paris that was about to disappear. This may be anachronistic on my part; it may have been less clear to people in 1900 that these vendors, who had been there forever, were so threatened. Certainly Atget would live to see the disappearance of many of these peddlers as part of the everyday landscape by the end of World War I.

At the time of this series there was a great impulse to photograph the *ancien régime,* the historic buildings and places of France that existed before the Revolution. In general, people photographed buildings that were threatened by progress or industrialization, and these tended to be the places for the rich or famous. For Atget to concentrate also on the tradespeople, who were threatened by these same processes, was another way of photographing the past without falling into the reactionary, nostalgic position that he was encouraged to adopt by some of his patrons, who were really interested in the essential, authentic France of churches and monuments, rather than the little people.

WN: It's important to place Atget in the context of a very long visual tradition of the representation of trades and occupations in Paris, a unique visual tradition in French art that started in the early eighteenth century, when suites of engravings were made showing the trades of the streets.

FR: This kind of representation was also very traditional in seventeenth-century engravings, in the work of Abraham Bosse, for example.

GB: Is the lampshade seller, however, a relatively new type of *petit métier?*

FR: It's not a new subject. Lampshades existed for candles, so there was a tradition there. And *abat-jour*—lampshade—is a seventeenth- or eighteenth-century term.

GB: Did Atget ever think of himself as practicing a street trade? Certainly he was in the street, and he had a one-on-one relationship with these people. I wonder whether his own mind worked in such a way that he could see his own practice being related to those of earlier artists.

FR: What is interesting is that he didn't change the way he photographed until the end of his career, so that was the kind of occupation that he was doing. But he called himself an author and editor, not an artist.

DH: If, as Françoise said, the lampshade seller is one of the few *petits métiers* pictures made outside of the general area in which Atget usually made them, and it's the only one that has an extremely long depth of field, I wonder if perhaps he was out photographing the streets that day and ran into this man and got him to pose. Because if you take the man away, it really is a view of the street. In a similar way to what I suggested for the picture in the Luxembourg Gardens, this also looks forward to the work that he did in photographing the streets of the city.

WN: We haven't talked directly about the categories that Atget established for his work. That would be helpful, so we can try to place this picture within the categories.

DH: Maria Morris Hambourg has explored this in depth in her 1980 dissertation and in the four-volume publication she and John Szarkowski produced for the Museum of Modern Art in the 1980s.

Atget's classification system is very complex and evolved throughout his working life, but its basic structure can be briefly described. It consisted of five principal series. The earliest photographs, which began in the late 1880s and the 1890s, were classified as *Landscape Documents*. They included botanical specimens and scenes in the countryside that he sold as studies and motifs for painters. Beginning about 1897, he began to concentrate on the historical core of the city of Paris, subdividing his photographs into two large groups: *The Art in Old Paris* and *Picturesque Paris*. The first comprised historical architecture, decoration, and sculpture, whereas the second was initially devoted to the *petits métiers* and later included

domestic interiors, shop displays, street circuses, and such areas of the city as the quays and the area beyond the city's fortified walls. To these series devoted to the city, he added a third in 1906, *Topography of Old Paris,* which was concerned with the city's urban spaces, its streets and public squares. Parallel to the series *The Art in Old Paris* was *Environs,* which dealt with architecture and its decoration in the small towns and villages surrounding the city. Finally, there were smaller series devoted to parks and gardens. That's the basic structure. The first two photographs we discussed, the possible self-portraits, are from *The Art in Old Paris.* This picture of the lampshade seller is from *Picturesque Paris.* He probably developed his negatives shortly after making them. When he developed each negative, he would assign it the next available number in whichever series he felt it would fit and then scratch the number on the glass plate. You can often see it in a lower corner of a print.

FR: The problem is that the number on the negative never tells us in which series he put that image. It's always a guess, and it's hard to check because the pages of his reference albums are very brittle.

GB: Also, he revised his series at various times and reassigned pictures to slightly different categories than he'd originally assigned them to. Sometimes he would take successive exposures of the same subject and assign them to different sections of different series.

DH: Atget had a very concise and efficient way of working with the hundreds of negatives he was producing and the varied clientele he had. After classifying his images, he filed them in reference albums, which allowed him to quickly identify those pictures that would be appropriate for a set designer, architect, or antiquarian.

MR: This makes an aesthetic appreciation of the work so tenuous. Even if we talk about a compositional structure we might see in hundreds of images, that still might actually not be as significant statistically as we'd like it to be, given the range of photographs taken and the purposes for which they were used. One of the ways Atget is of special interest for twentieth-century art is that there is always the concern with whether he was systematic or intuitive, or whether he was lucky—if you take so many pictures, some of them will be good—or if he was doing something very different from what we have created as a category for artists to do. He was

engaged in an enterprise that we call documentation, which rejects the highfalutin pedestal that people want to put him on, but he was not someone who said he just photographed to make money; he was ferociously dedicated to his craft.

WN: By about 1910 he'd already become very sensitive to who bought his pictures. A little notebook housed at the Museum of Modern Art shows how systematically he listed his possible clients. So we know that he sold to designers, illustrators, and even a category of person—the *amateur du Vieux Paris*—who loved the idea of the Old City. The notebook also has names of theatrical designers—people who were doing stage sets—and even more interesting to me is that he used the word *cinema,* for people who were designing the sets for films. He clearly was of-the-moment in terms of possible avenues for sales. He also listed the names of artists like Utrillo (see pp. 112–13). Atget may have been very intuitive in making an exposure, but he certainly was analytical in figuring out who the possible clients for his pictures were.

GB: His timing was also very good. When he started out to document Paris, the city was very interested in its own history. There were individual collectors of images and small local organizations as well as the grand national institutions like the Musée Carnavalet and the Bibliothèque Nationale. His interests seem to have been in perfect synchronization with what was being thought by Parisians about Paris.

MR: Historians have pointed out that France may be unparalleled in the resources devoted to the photographic documentation of its own past. There are lots of examples around the world of small organizations, and sometimes state organizations, that did this, but in France, a combination of these local and national groups devoted extraordinary amounts of money, especially from the mid-1890s on. Whether Atget was in sync with this or responding to market conditions is probably impossible to know exactly.

I think this bespeaks something very important for the history of photography in relation to France. There was an enormous struggle going on in the early years of the Third Republic about what the relation of contemporary France was to its past—what it meant to have a real history, what an authentic France was. People have used Atget since then to talk about that, but in the 1890s, certainly at least until the first decade of the twentieth century, these were vital questions, and

Maurice Utrillo. *L'Hôtel Scipion Sardini,* 1926.
Oil on canvas, 54 × 73 cm (21¼ × 28¾ in.).
Present whereabouts unknown. (See pl. 40.)

people came to great blows over them. I think Atget's work rests in the middle of that context.

DF: The next two pictures we're going to consider would definitely be regarded as documents of the ordinary in Paris, rather than the grand buildings. *Storefront (Little Bacchus)* (pl. 10) is dated 1901–2; a detail of the sign (p. 114) is dated 1908. The obvious question that comes to mind is, since the second photograph is a detail of the first, why the disparity in dates?

FR: The image from 1908 is a detail photographed from the other print. Atget could not enlarge his negatives, but he could make a detail by rephotographing a print.

GB: I suggest that the reason it took him seven years to make a detail from the first print is that someone said that they could not see from the original photograph

Maurice Utrillo. *La Fête de Vaugirard,* 1927.
Oil on canvas, 60 × 81 cm (23⅝ × 31⅞ in.).
Present whereabouts unknown. (See pl. 41.)

enough of how the metal had been wrought around the Bacchus figure. Or Atget
may have guessed that a metalsmith might want to see more detail of how the metal
had been worked.

FR: Someone who engraved pictures for publications might have used it too.

DH: I suspect this is a response to a potential commercial sale, and by no means
is this a unique example. In 1908 and 1909 Atget made details from approximately
fifty earlier prints, largely to do with metalwork and sculptural decoration.

WN: Someone involved with the art or history of metal design may have ordered
details to illustrate this subject. The creation of the master negative, however, some-
how seems to be a stroke of genius, despite what we would normally call a flaw, the
light leak in the lower-right-hand corner that casts a ghostly aura. In some ways it

Eugène Atget.
Rephotographed Detail of
"Storefront (Little Bacchus), rue Saint-Louis-en-l'Ile," 1908.
Albumen print, 17.6 × 22.7 cm (6¹⁵/₁₆ × 8¹⁵/₁₆ in.).
90.XM.124.8.

contributes to the element of mystery, with the woman lurking like a phantom (see detail on p. 138). But did Atget pose her? Was he working with her as a model? Was he deliberately creating a figurative composition, or was it an accident? Did she wait through the whole process while he got his camera mounted, or was she in the building, saw him doing his work, came over to take a look, and was accidentally recorded?

GB: I think the expression on her face indicates that she may not have understood why he was making this photograph. She looks rather suspicious of what he was doing. I would take it that she worked in this establishment. She had gone in and out of that door a thousand times, and she never thought it worth paying attention to—now why is someone making a photograph of it? And also of her? She must have realized that she was going to figure in the picture.

DH: This is very interesting. I would think that Atget's principal reason for making the photograph was to record the facade, particularly the Bacchus figure above. He presumably took the picture for clients who were interested in that type of decorative ironwork. But, as Weston said, the fact that the woman appears changes the image entirely. She becomes an equal center of visual interest, and in a way her presence distracts from the documentary purpose of the picture. What's extraordinary about Atget is that he somehow allowed these accidents, whether they were completely gratuitous or partly planned, to become part of his work.

MR: Through the woman Atget combines the documentary and the picturesque. He was creating documents that were going to be used by someone else to do something with, and this woman, as the picturesque, is in the document. I think some of the images twentieth-century photography viewers are the most drawn to are those in which the picturesque and the documentary are in tension with each other or combine somehow in an interesting way.

RF: What has been called the "punctum" phenomenon in photography is beautifully illustrated in much of Atget's work, and there is an intersection in this picture that illustrates that phenomenon. That conjunction should be underlined as part of the language of how we look at these pictures.

WN: Would you tell us how the word *punctum* relates specifically?

RF: The idea of punctum, which was proposed by Roland Barthes, relates to where the eye rests, regardless of the construct of the picture. When I look at this image, I see the head, and it's completely immutable. I cannot derive any information from it, yet I can empathize with it; it's the aspect of the photograph that I find fascinating. So that's the punctum.

WN: I go back and forth between the reflection and the face. I find that is also true with the self-portrait in the antique store window (pl. 12). I have a very hard time focusing on the portrait, because my eye continuously wants to go back and forth between what is behind the glass and what is reflected by the glass.

DF: This idea of a shifting focus is very apparent in *Hairdresser's Shop Window,* from 1912 (pl. 25), and *Storefront, avenue des Gobelins,* from 1925 (pl. 39).

GB: These two pictures tell quite a bit about the history of merchandising. Although they are displaying somewhat different products, the window in the avenue des Gobelins shop is spare in comparison with the absolutely crowded space in the hairdresser's salon. They're both trying to sell a kind of beauty, but the difference between 1912 and 1925 is evident. Atget was continually interested in how things were displayed—I think *étalage* is the French word for it. If he is thought of as being a photographer who had a passion for describing things that were about to disappear, I wonder if he was acutely conscious that the styles displayed in the 1925 picture were not going to be the styles of 1926 or 1927.

RF: That's a lovely précis. It really shows the individualities of the two works.

WN: Let's look at the other differences between these two pictures. In the earlier one, Atget seems to have gone out of his way to minimize the reflections by taking as oblique a viewpoint as he needed in order to eliminate them, retaining this multidimensional aspect only in the mirrored section on the right-hand edge. Thirteen years later, he seems to be glorying in the power of the photograph on a number of different levels. What's so astonishing is that the building across the street becomes dominant in each of the images.

We get to the point of intentionality again here. By comparing these two pictures, we are able to say that Atget really did analyze his subjects, and placed his camera strategically. We know that he could easily have eliminated the shadows by choosing a different viewpoint.

RF: I think he was doing two different things here. In the earlier image he took a picture of a window with all the stuff going on inside of it. He's photographing the interior space. A very different thing occurs in the other picture. In both works he is using a bottom corner to create a physicality of space, to locate you in front of the window looking in to the actual *étalage,* but beyond that corner in the 1925 photo is this incredible interior space that becomes an exterior space. He uses the sky in the reflection very much in the same way he did in outdoor pictures, as an open space. And if you look between the two mannequins on the right, there is the reflection of a man passing by on the street, a *flâneur* who's gazing into the window too.

WN: I have never noticed that detail before.

RF: There is the dome in the reflection and a circularity of the other forms; the X-shaped structures created by the mannequins' arms are similar to forms that you'll find in the pictures of parks and other subjects. That was Atget's signature way of dealing with how things appeared on the ground glass. This is relevant to your thoughts, Weston, about the intuitive and the rational. Atget was obsessed with taking pictures, and when you take pictures, certain habits form over time. Certain favorite constructs begin to reoccur.

MR: I think there is a change from the earlier window photo to the later one in their inherent sense of theater. There is tremendous theatricality in the 1912 photograph. It looks like a stage, with the window shade that is going to come down at the end of the day like a curtain. The figures appear more as if they're in costume, rather than the everyday wear of the bourgeoisie in the newer image, which has a different feel. The change from the street-as-theater perspective to a more popular one may be worth noting here. In the hairdresser picture, the way in which the coiffures allow Atget to explore layering is wonderful; the wiglets in the foreground move up to the busts, which then disappear into the background. There's

a dramatization there that he doesn't seem to have need of in the later picture, where he does it with more purely visual materials.

WN: We should also keep in perspective what was happening in 1925. This is the year that Berenice Abbott recounts her first meeting with Atget, that wonderful firsthand report when she says: "Shortly after arriving in Paris and seeing the first photographs of Atget that I ever saw in Man Ray's studio, I mounted the four flights of stairs to his fifth-floor apartment. On the door was a modest hand-made sign, *Documents pour artistes.* I returned many times, and we became friendly." So in the year this picture was made, Atget had met Man Ray and Berenice Abbott and told his best friend, "I'm a lost man; it's only the young foreigners who appreciate me." This statement suggests a sense of alienation. Somehow I see documentation in the 1912 image and alienation in the 1925 one, more of an expression of his own inner state of being.

DF: The next photograph we're going to look at is *Ragpicker's Hut,* from 1912 (pl. 26). Gordon, would you describe it?

GB: This appears to be a sweeter scene than it actually is. This is the shack of a *chiffonnier* on the outskirts of Paris. It's been made to look very domestic, with the vines growing up the side and stuffed animals on the roof. But in fact, this is a picture of desperate poverty.

I think Atget's social concerns come to the fore here. He also portrayed the ragpickers themselves, sitting in front of their hovels. Some of these homes were wagons; others were fixed in place, as this one is. It appears to be summer in the picture, since the vines are growing; what this place must have been like to live in during winter, one doesn't like to think.

DH: This is from the series *Picturesque Paris.* Atget's photographs of the ragpickers' dwellings came from a self-assigned project that resulted in albums that he sold to various public institutions.

FR: The ragpicker is a theme, like the *petits métiers,* that had been a subject for artists in the nineteenth century. The area where they lived was going to be demolished, so Atget wanted to portray them and the way they lived. Some of the rag-

pickers were very proud of their self-sufficiency. Atget's motivation was not only from his social conscience; these photographs were also part of his documentation of things that were going to disappear.

GB: It seems remarkable that he elicited so much cooperation from the *chiffon-niers* and their families. In a way, these pictures are more invasive than any of the others he made. The people may have been proud individually, but he really tres-passed on their turf in a way that he didn't in other pictures. They were willing to pose for him, and I think that says something about what Atget must have been like as a person, at least in dealing with the very lowest of the working class. He was able to communicate to them what he was doing and get them to say it was all right for him to be there.

MR: This picture brings to mind Atget's self-description of what he was doing, which was *archéologie*. But it's a funny kind of archaeology when you're dealing with a living culture.

GB: And your own culture.

MR: The people who lived here were being buried, their areas relandscaped by changes in society. So this picture really is a kind of archaeology, before they get buried. That adds a certain poignancy to the image.

Robbert used the term *punctum* earlier, and the shoes here have that function for me. One of the things they may speak to us about is a desire to keep the inside of the house clean—you take your shoes off before you go in. And look at the care with which all the little dolls on the front were placed. The decorative impulse amidst the ruins again combines the documentary and the picturesque in a very moving way.

RF: Gordon, you wondered how Atget could establish rapport with the ragpickers. These pictures seem to have a kind of empathy with place and time that is trans-lated in the act of how you set up a camera and how you enter into a place. As Atget got more certain about the pictures he wanted to make, a presence and gesture attached to the act of being there comes through in the images.

DH: Can you talk about that in relationship to this picture?

RF: There is a sense that he has located the camera right at the borderline of that particular environment. If whoever lives there were to create a boundary, the camera is probably right on the edge of it. It's in that sense that I think Atget communicated with the people who lived there.

GB: That idea surprises me, because this empathy, this ability to integrate with other people—of a different class, if you will—is somewhat at odds with descriptions of what he was like when dealing with the American artists of the 1920s.

RF: But that was a very different thing because of the social exchange of Americans entering into a French cultural situation.

GB: I think we have to say he must have been an extraordinarily sensitive man.

RF: He couldn't have done it otherwise.

MR: It's hard to know, given the stories about him. Not only foreigners but even his friends talked about how difficult he was. André Calmettes said, "He was as absolute about his hygiene as he was in his art."

WN: This picture, to me, is exemplary of Atget the collector, the man who used the camera to possess something that he couldn't possess in any other way. The idea that he would want to possess the ragpicker's house is extraordinary. In my opinion, Atget was not expressing much empathy for the people who lived here but rather was pointing to what they had created.

GB: This is also a picture of a collector himself, because who better than a ragpicker would be able to find the objects that have been attached to the walls of this building. Somehow having collected all of these things and then using them as decoration indicates a sensibility on the part of the occupant, not only in the growing of plants to beautify the place but also in using what is literally the trash of the past as raw material.

DF: The next two images, unlike many that we've seen today, are more representative of what the general public would say are typical Atget photographs. The first, from 1915–19, depicts a reflecting pool at Saint-Cloud (pl. 28); the second, dated 1921, a sculpture at Versailles (pl. 31).

GB: Atget made many beautiful photographs of the gardens of the *ancien régime,* but I think it belittles the work to conclude that this is the height of his achievement, ravishing as the images can be. These two pictures seem to be linked, because one expects that he has gone around and made a photograph of each statue. The garden at Saint-Cloud, however, was an especially personal investigation for him after the war. The pictures he made there seem to have been more for his personal pleasure than for sale. I'm tempted to think of the statue from Versailles as being Europe weeping over the losses of the war that had just ended.

WN: We don't know exactly what Atget did during the war, but it seems that he spent those years looking at and revising his life's work. The two pictures we looked at from before the war, from 1912 (pls. 25–26), are of Atget observing chaos; then, having experienced the war and its emotional catastrophes, he suddenly looked at what was around him in what would appear to be a new, very clear-headed and organized way. Suddenly the photographs become much more pictorial. What accounts for this transition?

GB: I suspect that his very house was probably shuddering with the bombardments of World War I. That was a period of real deprivation in terms of foodstuffs; his income had been reduced to zero, although he'd been thrifty and saved money. With the 1920s, there was a sense of possibilities again. He was in his sixties and his health was not good, but at least there were lyric possibilities of the spirit.

MR: In the other pictures we've looked at, you almost want to quiet the world down so that you can pay attention to them and let them work their magic on you. But these two seem almost bombastic in their allegorical directness; the move to metaphor is accelerated. The earlier pictures are tremendously rich in metaphorical possibility, but you have much more freedom to respond.

Some biographers say that Atget's work becomes more personal after the war. It's certainly the case that France's relationship to establishing its own history was different. The use of remembrance from 1916 to 1925 was very different than it was in the 1890s and the first decade of the twentieth century. It was dominated by death, and it was all about rituals of commemoration, of youth cut off. That is a very different enterprise than the search for historical essence, for the real France,

that we saw earlier. It may be that Atget was thrown back by the marketplace and by these other deprivations into examining what he could do—"What am I good at? What are the things I can respond to effectively?" I think much of the late work answers that impulse very successfully and finds even richer veins of ambiguity. I don't think the picture of the Versailles statue is one of those examples, however.

GB: It strikes me that Atget's feelings after the war returned to a kind of innocence about a pure and classical French culture. It's strange to contrast him with Proust. In the last volumes of Proust's great series, everything is suddenly quite decadent; things are revealed as being very impure, not what they seemed at first.

WN: There's also an element of mood. *Ragpicker's Hut,* as you could tell from my description, I find to be a joyful picture because of its ennobling of what the *chiffonnier* has created. Whereas here I think Atget is really moving in a very melancholy direction.

GB: Saint-Cloud is an unusual site. The old palace there was burned down in 1871. This garden extends out from where the house had been, becoming a formal exercise in space that is not connected to architecture. I think that makes it a peculiarly abstract environment.

DH: The way this pair of images was introduced seems to imply that this was a new subject that Atget was treating, but in fact, he had extensively photographed both Versailles and Saint-Cloud before the war. One can find melancholic pictures in that body of work, so I don't think, by themselves, that these pictures can be used as the basis for a new vision.

Also, in November 1920 Atget sold more than two thousand negatives to the French government. He received ten thousand francs for them, which was a great deal of money. In addition to having a substantial portion of his work preserved by the government, and no longer needing to care for those negatives, he also found himself with money and the freedom to work. I think that his returning to these places is more complex than simply a change in his mood.

RF: The Surrealist idea of the simultaneity of divergent views really resonates for me in the Saint-Cloud picture. This seems to be a normal view, but it is completely out

of the ordinary. I can fall in love with the way the chestnuts are flowering on the trees and at the same time be outraged by the abstraction of the chestnut tree on the right into some sort of strange shape to which the statues are reacting. There's a Surrealistic simultaneity of perceptions taking place here that goes to another level from what we have dealt with before.

GB: Why does that water look so impenetrable? It looks so much like a mirror, or perhaps it's just the color of this particular print.

RF: Because of the way the reflections are recorded, it looks like early morning on an overcast day. The long exposure created that strange sheen on the water, and the rippling that you can see because of the rain softens the sculptures' reflections. It's a passage of time that's being rendered, and that's why the water reads so strangely.

MR: At this period, what would the exposure be? Do you have any guess?

RF: I would say a quarter- or a half-second.

MR: I've always thought, when I've heard people talk about Atget photographing time, that they were speaking figuratively, but in fact, we're also speaking physically.

DH: About the length of exposure.

MR: Yes. About the creation of a trace of time through fuzziness, or through shadows, or through a softening of focus.

WN: The trees on the left are so carefully shaped, and their shape translates into the reflection, but the branch on the right very conveniently creates an almost sculptural form that goes back to the element of the accident of nature.

RF: That's the form I saw as Surrealistic, but it's not created by an accident of nature, I think, but because Atget was very good with his camera. By placing his camera where he did, he made the trees on the right read as one mass, when it is really a set of staccato trees moving down the path like those on the left.

DF: Where Atget placed his camera is very important in *Old Mill, Charenton* (pl. 27).

WN: This picture is from 1915, so it was done during the war.

DF: To me, this is an amazing photograph because of the way the shapes intersect to flatten the picture space.

GB: I think of this as being Cubist. It's very difficult to read the actual picture planes.

DH: Atget took several pictures of this mill from different angles. This is only a partial representation; in the group context, the entire structure is revealed. He normally took several pictures that progressively work their way around a structure.

WN: For me, this image deals with something that we haven't talked about so far today—the phenomenon of visual perception. What I mean is that as an artist, Atget manipulates perception by using the single lens of the camera to duplicate what we see with two eyes. I want to look at the awkwardly shaped dark area in the center of the stream—that is my punctum here—even though I don't know if it's the reflection of a tree or a gravel bank exposed by the low water level. But at the same time, something pulls my attention in the opposite direction. Atget has created a composition here that somehow attacks the visual process; I literally feel my eye muscles stretching.

GB: To me, this is a schizophrenic picture, a little like the effect of wearing one contact lens for distance and another for seeing up close. We're being asked to look at two different planes, and the spatial displacement makes this somewhat uncomfortable.

MR: Does this qualify as a melancholy picture?

WN: For me, no, because I find the visual energy pulling in two directions animating. I would have to use the word *dynamic*.

RF: I don't think of it as melancholy, but as having a very dynamic emotion.

MR: That's true, but I see elements of dislocation that are melancholic. The mill has no wheel, and if it did, no water to turn it. That metaphor is there. Knowing that it was done during the war, and having this structure that both directs and obscures our vision, creates a dynamic visual enterprise. At the same time, what I find myself seeing is dislocation and confusion and something running dry.

WN: Another word I might choose would be *ambivalent.* This work is almost the epitome of that. An ambivalent picture places the responsibility on the viewer. Each of us brings to that ambivalence something that turns us in one direction or the other. I tried to describe the process that turned me in a particular direction, but I can easily see how, for the reasons that you just described, Michael, it could turn in the other direction.

MR: There are several things that I can't help looking at in this picture; it would be wrong to say they give me pleasure, because they are disturbing. When we've talked about reflections today, they were of something, but here the reflection on the stream surface is almost one of emptiness. It takes your eye to the distance and then down either the water or the road. But my eye keeps going back to the window on the upper floor. It seems like a horror-filled point in the photograph that gives it a shadow of sadness.

GB: I think there is a distinct air of depletion here, and since the mill wheel is gone, of emasculation. There is something sad about this place.

RF: This is the first image where I really see Atget translating, even by chance, a picture into a print. The tonal values that are set up within the frame allow the translation from three dimensions into two. This photograph has a real sophistication in the alignment of the different picture planes.

DF: Intellectually we know all the sky areas in the picture are distant, but because of the way Atget organized the composition, the sky we see through the arch reads as distant while the sky to the right appears to be on the same plane as the building. I find that perceptual twist really fascinating.

WN: Gordon used the word *Cubist* to describe this, and I think that's the element that creates these dislocations. Let's return to that dark area I referred to as my punctum. If Atget were a painter, he could not have found a mark that was more perfect. This, of course, goes back to the accidental qualities that appear in a picture that, as we've been discussing, is mostly about structure.

DF: Moving back to the 1920s, we'll look at two images from the streets of Paris: *Rue Cardinale,* from 1922 (pl. 32), and *Panthéon,* from 1924 (pl. 36).

DH: These are both sites that Atget photographed throughout his career. He first photographed them in 1898 and returned to them periodically. For example, he subsequently photographed rue Cardinale's intersection with rue de l'Abbaye in 1899, 1903, 1910, 1922, and 1924.

What is extremely interesting when you examine a series of pictures made over a period of years is how Atget changed formats. When he photographed the streets prior to the war, he used a vertical format. In the 1920s, he generally switched to a horizontal format, which creates an entirely different problem for composing a picture.

RF: Was he using the same materials?

DH: Yes, as far as we know. The other change is that, prior to the war, all the photographs were made in the middle part of the day, late morning to mid-afternoon; sometimes on overcast days. After the war, he increasingly tended to photograph in the early morning. I suspect that *Rue Cardinale* was taken at dawn, or shortly thereafter. *Panthéon* was made after a rainstorm.

In addition to approaching the streets with a different format, Atget also sought out particular atmospheric conditions in which to view the city. Light at dawn is soft and enveloping, as opposed to midday light, with its prominent shadows.

DF: Even in the postwar years, there was surely a lot of urban activity in Paris, and lots of automobiles and trucks. So many of the street pictures from this period are devoid of vehicles that it's clearly a choice Atget made. The emptiness makes them seem like photographs of the past, not documents of a present time.

MR: I wonder if we could think a little bit about what drew him to this corner on rue Cardinale?

FR: I think what attracted him was that it's like a theater set.

MR: Looking at the buildings, I'm trying to see what's remarkable about them, if anything. It looks like each corner may be of different material, and the buildings are probably from somewhat different periods.

FR: Yes, they are.

MR: The paving stones have been taken up and the street has been paved.

DH: That happened between 1910 and 1922.

MR: And the streetlamp has to be electric by the 1920s.

GB: This is a disjointed intersection; the streets don't make a perfect cross.

MR: Yes. That gives the view a kind of asymmetry, both chronological and spatial. Perhaps one of the things that's working here is the asymmetries between the different kinds of windows, the different kinds of building materials, and the corners that don't actually meet.

FR: It's also relevant that he had taken this picture before. He may have been interested in taking it again because he had sold some of the earlier negatives.

DH: That would be one practical reason, that he wanted to replenish his stock.

MR: But of all the corners in Paris, why did Atget come to this one?

DH: He did a lot of pictures in this arrondissement.

WN: If that's the case, then Michael's question seems even more relevant. Why is he spending so much time at this particular intersection? In other pictures we've discussed, Atget organized his compositions around certain objects being in a perfect position. Here it's much harder to apply formal analysis for a clue as to why he would come back to this spot on several occasions.

RF: I think it has to do with the way in which the rue Cardinale curves and with the visual effect caused by the light building on the corner and the slightly darker building behind it.

GB: The corner of the white building is precisely in the middle of the picture.

RF: That's right, and the asymmetries provide wonderful pictorial ways of organizing a composition. What I suggest is that he returned here simply because it's a good place to take a picture.

MR: In the image of the Panthéon, what is the round thing on the sign on the left, toward the bottom of the picture?

FR: It's from a drawing in an advertisement for an alcoholic drink.

RF: I have an exceptional affection for this picture, because of how it is about the place itself, with those wet cobblestones, and how Atget brings deep space closer with the lamppost adjacent to the building on the right. It echoes the little church spires on the top left side. They're almost the same shape, and those echoes are so willfully placed in relation to the beautiful open space in the foreground.

GB: The dark form that's right behind that streetlight is the point of a triangle created by the building on the left, and that pulls the sides together.

RF: Exactly. It's beautiful. And again it has to do with where Atget put his camera.

WN: What always intrigues me about this picture is the vertical line that, almost as though drawn, blocks out half of the main subject, the Panthéon, and the incredible fortuitousness of the shadowed shapes echoing the dome. It almost seems preordained. But this, of course, leads me to think about Atget's modus operandi. He generally avoided famous buildings like the Panthéon.

FR: He went inside the Panthéon and did a lot of interiors.

WN: But of the other grand monuments, it's only the churches that he went into regularly. He didn't photograph government buildings like the Assemblée Nationale; he didn't photograph the Arc de Triomphe.

GB: He photographed the grand buildings of Bourbon Paris, the Paris of the *ancien régime,* but he very rarely photographed important buildings subsequent to that era. The finished Arc de Triomphe is a little later, as is the Assemblée Nationale. In part, the interest of Atget's time was the buildings of an earlier period of French history, not more recent ones.

DH: And even with the Panthéon, Atget didn't make the traditional view looking up the rue Soufflot, but views from the side in order to set it within the context of the quarter.

MR: Is it possible that what he is photographing here is not the Panthéon but the corner and the place?

DH: Oh, absolutely. I think at this point he was no longer interested in separate buildings, but in their urban context.

MR: And the Panthéon just happened to be there.

DH: In the same way that the subject of *Rue Cardinale* is the intersection, here he gives a lot of attention to the street itself. In both pictures he could have tilted his camera up and eliminated a large portion of the foreground, but that space had become an important subject for him.

GB: It gives our feet a way to walk into the picture; we can step forward and be there too.

RF: That takes us back to Atget's empathy and to a recognition of borders and where you locate yourself. All of a sudden, this is not a photograph about what has been—the picturesque—but an image about that intersection.

MR: But the Panthéon is not just any monument. I can't help but think about what it represents in relation to what Atget did. It had been a church, but from the Revolution on it was taken over as a place to honor the dead of the Republic in a secular way. The cross is prominently displayed, but even its being there was very contentious. In some ways the Panthéon is a memorial palace, so I'm hesitant to see it as just another building. Its practice in some ways has a kinship with some of Atget's practice, and in his time it was a great center of popular agitation. In the second half of the nineteenth century there were fights about who deserved to be there and how secular it should be. So it's not just another monument; it's one that exists in relation to the church of Saint-Étienne-du-Mont on the left and to this corner. But it also stands out from them; the photograph gives us an almost reverential perspective on it.

WN: I'd like to talk about the romantic, atmospheric qualities here. This seems less of a document and more of an attempt to compose a picture that has a completely independent reason for being. That's a level that we know Atget could achieve, but he had not done very many pieces like this before. And he only has three more years to live; he's now almost seventy. Are we dealing with a changed perspective in old age?

GB: Perhaps we should remember David's thought earlier; Atget was financially independent at this point.

MR: I am ambivalent about this issue in some ways. On the one hand, I am attracted to the view that, in his final years, Atget was liberated to be Atget. There is a kind of pathos in that; we want that to happen to somebody we think is a talented artist. On the other hand, one could talk about the Panthéon picture as slipping into old-fashioned Pictorialism. In other words, if we make art the thing to which Atget was supposed to have aspired, and say that if he had only had enough money, he could have made pictures like this and not done all the other things we've looked at, then he wouldn't be Atget. He would be another kind of romantically oriented pictorial photographer who didn't move into the twentieth century. It's easy to fall into what I think of as a rather obvious ideology of art that Atget may never have shared, even when he was free to do his own work. Maybe he stuck to his guns.

RF: I think he probably stuck to his guns here, especially after what you said about the history of the Panthéon. This is a very clean picture; it just happens to have atmospheric qualities that we identify with Pictorialism. But it also reflects a real condition of how the streets of Paris can be on a foggy, rainy day.

DH: Also, he did sell this picture. The Musée Carnavalet and the Bibliothèque Nationale bought it, so there was clearly a market. I've always thought about this in terms of the shift in how old Paris was perceived after World War I. There was a switch from preferring realism for documentation to an appreciation of something that was clearly perceived to lie in the past.

MR: Do you mean that in Atget's earlier work things were always about to disappear, but in the later work there is a sense of nostalgia because the subjects are already part of another world?

DH: That's right. After the war there was a shift to wanting to acknowledge the twentieth century, to be modern. The interest in preserving the character of old Paris still remained, but it was no longer a central thrust of the culture. Seeing the city through specific climatic conditions may also have something to do with the influence of Impressionist painting—the atmosphere of the city became an integral and essential component of its character.

WN: Another element that perhaps should be taken into consideration is that in 1925 there was a rediscovery of photography as a medium of creative expression in Paris. An exhibition created that year showed the experimental younger photographers in Paris making photographs as art. Man Ray had just arrived on the scene from New York. There were a lot of younger artists having exhibitions of photographs as works of art—not pictorial photographs that were imitating paintings and drawings, but something that could be called the new vision.

Michael suggested the Panthéon picture was neopictorial, but the reality is that it was made at the very moment when this new recognition of photography as a credible form of expression swept over Paris. So the question is: Is it possible that Atget was somehow influenced by this and that this image is his manifestation of what he thought a great picture should be if it were considered as a work of art? I think this is one of the strongest pictures he made, certainly of the non-proto-Surrealist or Dada works. What would have inspired him suddenly in 1925 to create such an affecting image?

FR: But this one, with all this atmosphere, is the extreme one. When you look at all the images we bought during this time, they are almost all very atmospheric pictures. You can recognize that they are from this period. And if you really look at them, you feel they are like 1930s images. If you didn't know this was by Atget, and if it was more of a standard black-and-white print, you might say it was by Kertész or Brassaï.

DF: The final print we'll discuss today is *Sideshow Attraction, Fête du Trône*, from 1925 (pl. 42).

GB: This image was a great favorite of the Surrealists. It shows a booth at one of the street fairs in Paris in which a giant and a midget apparently appear. There is a chair for each of them, appropriately sized, a shoe for each of them, appropriately sized, and two photographs of them (see detail on p. 132).

FR: The signs say *Entrée un franc*. You pay one franc and see the men inside.

WN: It's also of interest to know that Atget photographed the fairs themselves. This picture stands out as being different from what seem to be more documentary pictures of the fairs' exteriors; was it part of a sequence?

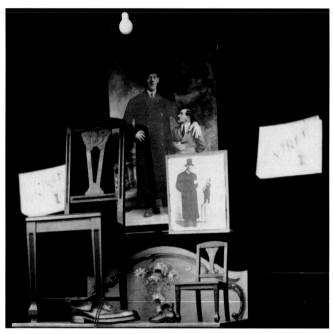

Eugène Atget.
Sideshow Attraction, Fête du Trône,
negative: 1925; print: circa 1954 by Berenice Abbott
(pl. 42, detail).

DH: Yes, the preceding picture in the numerical series shows an oblique view of the whole structure. This context is entirely lost when this is seen in isolation. Of course, the Surrealists were not concerned with such descriptive contexts.

MR: I think of Atget as a kind of bridge between Baudelaire and the Surrealists. We know Baudelaire as the poet of *flânerie,* of walking through the city, and of course Atget is the ambulatory photographer. The thing about Baudelaire that is really crucial in this regard is his poetic inspiration. Atget seems to be perfectly in accord with this in saying in this picture that these innocent monsters in the street fairs are a central feature of modernity, that modernity produces these kinds of people in a way that sends them to the margins, and the task of a poet—and he as a photographer—is to find them.

The Surrealists, of course, radicalized this; the word *innocent* was no longer appropriate. All they needed was something monstrous, something out of the ordinary, something that could be used as a weapon against the mainstream of society. This idea interested Baudelaire, like any other exciting thing, but it probably didn't interest Atget. He was more of a traditional socialist, I think, than that.

GB: If Atget is a Baudelairean *flâneur* with a camera in the streets, then his self-portraits in the street windows are like the anecdote recounted of Baudelaire tipping his hat to himself in a reflection in a store window, not quite realizing it was himself, thinking that he had seen a friend.

DH: This print was made by Berenice Abbott. It's extremely beautiful, but it wasn't printed by Atget with his usual printing materials. I think that, in fairness to him, it would be better to assess one of his albumen prints, such as the one in the Museum of Modern Art's collection.

WN: To take this one step further, you might point to the inky black background in this print and suggest that, had Atget printed it, there might have been greater detail or a dimensionality there.

DH: It would certainly have a different color and a less austere feeling.

WN: I'm interested in your candid response about where you feel this picture rests in the entire body of work. We've talked about its relation to modernism and the Surrealists, and we've already admitted that this print was made by Abbott, so we have a bit of a problem in terms of fitting this photograph into Atget's oeuvre. But intellectually, do you think this is beyond the line? The negative was made in 1925, he died in 1927, and the print was made about 1954. Do you think it is outside his body of work?

RF: It's different in the sense that it's such a simple picture. There are echoes of what you find in the rest of Atget's work, but it's so simple that I almost say no to it. It doesn't quite fit.

WN: Is this an accident?

RF: I don't think it's an accident in the shooting, but rather the way in which it has been broadcast across the world and the way in which we perceive it. Whereas in most of Atget's pictures, I see Atget as the operating mind-set.

GB: I would see it as the punctuation at the end of the sentence that is his career.

MR: Given the project that Atget seems to have had, it would be surprising if there weren't a carnival included at some point. There's a carnival dimension in some of the *petits métiers* shots; there's a sense that these things have become carnivalesque as progress and modernity dominate the city. I don't think of this as that anomalous in his work.

FR: I think many of Atget's photographs are very graphic, that he's not always a three-dimensional artist. Some of the other images he made at the fairs are also very flat, and some of the carousels are very graphic, with almost no depth. This is exceptional, in a way, but it's still Atget.

DF: To end our conversation, I'd like to ask each of you for some concluding thoughts about Atget or about what we've discussed today.

MR: I think that Atget's work raises so many wonderful and, in some cases, troubling questions. We've come back to them several times. A simple version of the issue is whether these photographs belong in an art museum, because the question of art has been so much at the center of our discussion of Atget. I want to mention a couple of the ways in which that question has come up, and how it actually advances our thinking.

One, which we didn't really identify as such although it's been implicit, is in the problem of the series. So much of modern art, and art for centuries in the West, has been based on the individual work of art. We've spent some time expressing our opinions on how certain pictures seem to jump apart, and that is tied to our notion that what counts as a work of art is its ability to stand on its own. One of the things that is striking about Atget, and I think this is intrinsic to the medium of photography, is that he makes the series a contender for a work of art.

Also we've come back again and again to the question of authorship, whether through accident, intention, intuition, or organization. Atget seems to

reject the mantle of author, of master, of genius, while at the same time he was ferociously dedicated to his craft. I found Robbert's idea of habits really helpful in imagining how a figure can cultivate his capacity to see what the picture should be and then turn that seeing into pictures that we can value or not. I don't think it's right to think of Atget as a documentary photographer in the sense that we've come to apply the term in the twentieth century, but as a producer of documents.

There again, the question of the relation of a document to a work of art is insistently posed by Atget's work. There are times when his documents are unavoidably beautiful; they grab us by our souls or our hearts. For me, the mill picture is obviously valuable as a document, as a production of knowledge, but at the same time it seems silly to describe it only in those terms because it is doing something else. Does that mean it jumps apart from a series, or that the series somehow becomes a part of this power? That I surely don't know.

But I do think that the way Atget's work functions at these different levels is part of why, no matter if we come to him from history or memory or art, the work seems to have an undeniable power.

GB: I find the work fascinating because, on its surface, it's so solipsistic. But in fact, on examination, it was created by a mind that took a whole city and its life as its subject matter. When one examines the organizational principles of the work, it turns out that one is being immersed in a world that has been organized by a quite singular and unusual mind. And that in itself is a fascination.

DH: For me, part of the problem of looking at Atget is how to interpret his work. Although we didn't talk about it directly, it seems to me that how you think of Atget as a person and a photographer becomes the basis for your interpretation of him; I think this can be borne out historically. The Surrealists, for example, saw him as a naïve primitive without any consciousness of the significance of what he was photographing. They could, therefore, take different pictures out of their original context and give them a new one. Their way of thinking about him provides the basis for their interpretation of his work. Similarly, if you see him as a twentieth-century artist or as a commercial photographer or as a documentary photographer, then you necessarily look at his work in a particular way and emphasize different aspects of it.

It's repeatedly struck me that Atget's body of work is of such enormous size and complexity, and that even though it can be described as having a specific subject matter of documenting the historical core of the city, the work changed and developed, altered and shifted over time. It's very difficult to summarize. Part of the interest for me in our discussion today has been in examining the late pictures, trying to see where they connect with earlier ones, and acknowledging that certain pictures don't seem to fit and that there are inherent complexities through the entire body of work.

That's the first point. The second is that Atget was, as were many photographers, a largely silent man. There are a few extant documents and a few recorded remarks—his business cards, for example, or his famous statement to Man Ray that he just made documents. I've always been struck by his comment to Berenice Abbott, as she's recalled it, that he didn't work under commission because people didn't know what to photograph. In a clear and concise way, that indicates complete self-confidence in and self-awareness of what he was doing. The result, I think, is that the meaning of Atget's work resides in the work itself and in an exhaustive analysis of it.

RF: Atget presents for me my first encounter with a possibility of tracing the process of a willful praxis, and to see that unfold over time. Most of the time, especially in photography, there is a five- or ten-year stretch in which an artist has the intensity and clarity of the first blush of a love of encounter. What happens with Atget is that I can visually trace the first encounter, the experience of "Eureka!" This is related to an encounter with a physical site, to a narrative that evolves to a mental site that has to do with the idea of a picture that has been rooted in reality but now is something completely different. The print is a piece of paper with some markings on it, but markings that come out of the willful pursuit over time. Atget was the first example of that for me.

FR: Initially, Atget was, for me, a large bunch of boxes in our collection. Specialists would come and look at these images that were bought directly from Atget during a period of thirty years. Another large group of images, almost four thousand, was bought by our museum in the 1950s. Little by little I began looking at, and

entering into, the photographs. At first they looked quite flat, only a surface. Now I think I have gone into the frame with Atget, but it's only just the beginning of the discovery. This colloquium is one more step in my knowledge of and fascination with the work of a photographer who, in his time, was thought of as somebody who perhaps was not so skillful. But now we think he is very skillful. It is really interesting to see the status of these images change in the collection, and historically as well.

WN: My perspective on Atget comes, I think, largely from my great admiration of his ability to shift between deliberate action and harnessing accident and chance. And I admire his equivocal spirit and the way he could make ambiguity something that fascinates, when usually ambiguity is something that we want to avoid and ignore. I guess the admiration for that trait comes from our understanding of experimental art of the early part of the century, when ambiguity became the main subject for a lot of work. He shared something with those artists, and we've learned from those artists how to understand and appreciate Atget. I certainly have learned to appreciate him through that particular lens.

For me, Atget's genius was to make pictures with an astonishingly homogeneous cohesion and internal consistency formed from what seems to me a miraculous amalgamation of intuitive action and rational analysis. In the end I have to agree—even though I don't agree with everything that the biographer Calmettes said—that Atget was a genius because he maintained this equilibrium between a fact and a dream, and that is so difficult to do. It's like walking a tightrope continuously. In every picture we're watching a man on a tightrope trying to avoid falling off the wire and, at the same time, giving us a fact and a dream that we can take away with us.

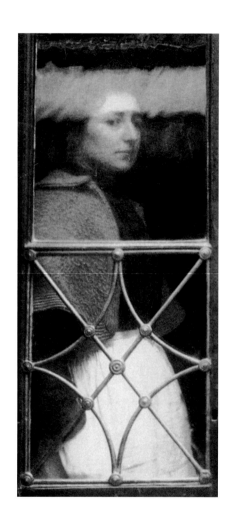

Eugène Atget.
Storefront (Little Bacchus), rue Saint-Louis-en-l'Ile, 1901–2
(pl. 10, detail).

Chronology

1857

Jean-Eugène-Auguste Atget is born on February 12 in Libourne (Gironde), France, near Bordeaux, the only child of Jean-Eugène Atget, a carriage maker and saddler, and Clara-Adeline Atget, née Hourlier. He has neither siblings nor cousins.

1859

The family moves to Bordeaux, where Atget's father becomes a traveling salesman.

1862

Atget's father dies in Paris while on business; shortly thereafter Atget's mother also dies. He is taken in by his maternal grandparents, Auguste and Victoire Hourlier. His grandfather is a clerk at a freight railway station in Bordeaux.

Circa 1863–77

Atget attends school in Bordeaux and then goes to sea, initially as a cabin boy and perhaps later as a full-fledged sailor on voyages that may have gone to Uruguay and Africa.

1878

In the fall, moves to 97, rue de Flandre, La Villette, a seedy area of Paris. Applies for admission to the National Conservatory of Music and Drama, the most important French school for acting. He is rejected and soon thereafter is drafted into the army to serve five years of compulsory service.

1879

Moves to 50, rue Notre-Dame de Lorette. Reapplies to the same acting school and is admitted in the fall. While serving in the infantry, he fitfully attends classes.

1880–81

Continues in acting school, but in January 1881 is dismissed before graduating, making it impossible to hope for a career in the established French theater. His grandparents die.

1882

In September, is released from military service a year early as he is now entirely without family. Moves to 12, rue des Beaux-Arts, and begins to meet art students and artists.

1883–86

Plays minor roles with traveling theatrical troupes in the provinces, in the suburbs of Paris, and perhaps at the Théâtre des Nations in Paris itself. Meets and forms a lifelong friendship with André Calmettes, an actor who later becomes a successful director of plays and movies. In 1886 Atget meets Valentine Delafosse Compagnon, an actress who becomes his companion. She is ten years older than Atget and has a ten-year-old son, Léon.

1887–88

Leaves the stage and Paris and experiments with painting before deciding upon photography as a new career. Becomes sufficiently established at Clermont (Oise) as to have made up an ink stamp with which to mark the back of his prints.

1890

Moves to 5, rue de la Pitié, in Paris, where he hangs out a sign that advertises that he makes "documents for artists." Painters like Luc-Olivier Merson and Edouard Detaille begin to purchase his photographs, the subject matter of which at this point is animals, plants, and landscapes. He also begins a series that he later calls *Vieux France* (Old France).

Circa 1897

Begins to photograph Paris. He starts the series *L'Art dans le Vieux Paris* (The Art in Old Paris), which he will continue until his death, and *Paris pittoresque* (Picturesque Paris), which he continues until 1900 and then resumes in 1910. The latter includes his studies of street tradesmen—*les petits métiers*—and images of modern life in Paris.

1898

First sales of photographs to governmental institutions, the Musée de Sculpture Comparée and the Musée Carnavalet. The sale to the latter is accomplished through an agent, but by 1901 Atget makes sales to the museum directly. Although interrupted by World War I, they continue until 1921.

1899

Moves to 17 *bis*, rue Campagne-Première, in Montparnasse, a new neighborhood that will become a traditional quarter for artists. He and Compagnon live here until their deaths. First sales to the Bibliothèque Historique de la Ville de Paris, to which he continues to sell until 1914.

1900

First sales to the Bibliothèque Nationale, the Musée des Arts Décoratifs, and the École

Eugène Atget.
House on the place du Caire, 1903
(pl. 13, detail).

des Beaux-Arts, all of which become steady customers for his work.

1901

Begins his *Environs de Paris* series, which continues, with interruptions, until the end of his life. It contains the photographs he makes outside of Paris proper. Continued sales to institutions.

1902

Begins to style himself as an *auteur éditeur* (author-editor) on his business cards and stationery. First sales to the École Boulle.

1904

Lectures on Molière at a neighborhood community center. Until 1913 he will occasionally lecture on theatrical works by Musset, Hugo,

Molière, Racine, Ponsard, Dumas *père* and *fils,* Augier, and Schiller at such centers as well as at more-distinguished institutions.

1906

Begins a series on Paris topography, to which he makes annual additions until 1915, pauses during World War I, and then finishes in 1919.

1907

The Bibliothèque Historique de la Ville de Paris commissions a topographical survey of several Parisian neighborhoods, the most important commission of his career, providing him with an adequate income. He makes a series of fifty-five photographs at Rouen.

1910

Assembles albums of his photographs on the subjects of *L'Art dans le Vieux Paris; Intérieurs Parisiens, Début du XXe Siècle, Artistiques, Pittoresques & Bourgeois* (Parisian Interiors, Beginning of the 20th Century, Artistic, Picturesque & Bourgeois); and the fortifications, boutiques, and rag-pickers of Paris for sale to the Bibliothèque Nationale and the Musée Carnavalet. He sells other more-specialized albums to individuals.

1911

Donates to the Bibliothèque Historique de la Ville de Paris his large collection of radical socialist and unionist newspapers.

1913

Undertakes a series of photographs of urban demolitions.

1914–18

Atget makes almost no photographs during World War I. Sales to institutions virtually cease after 1914 and do not resume until 1919. Because of the German bombardments of Paris, he safeguards his negatives by storing them in the basement of his building. Some, however, are damaged by the damp. He inventories and revises the numbering system for his negatives and prints. Sells some images to the Pathé and Gaumont motion picture companies. Sells his collection of newspaper articles on the Dreyfus Affair, which he had been assembling since 1896, to the Bibliothèque Nationale in 1917. Léon Compagnon is killed in combat in 1914.

Eugène Atget.
Rue de l'Hôtel-de-Ville, 1921
(pl. 29, detail).

1919

Begins to photograph again.

1920

Sells for ten thousand francs more than two thousand glass-plate negatives to the Service Photographique des Monuments Historiques, assuring himself of adequate capital for the first time in his life.

1921

André Dignimont commissions a series of photographs of Paris prostitutes, intended as illustrations for a book.

1922

Establishes and augments a series made in the gardens at Versailles and another at Saint-Cloud. He works on these in 1923 and 1924 and again in 1926.

1923

Makes a series of photographs in the parks of Paris that he continues in 1925 and 1926.

1924

Photographs by Atget appear in the journal *Paris-Quartiers.*

1925

Atget meets Berenice Abbott through Man Ray, whom he had met sometime between 1921 and 1925.

1926

Makes a set of sixty photographs at the park at Sceaux outside Paris. Valentine Compagnon dies on June 20. Atget's health rapidly declines. Four images by him are reproduced in *La Révolution surréaliste.*

PHOTO
E. ATGET

COLLECTION
BÉRÉNICE ABBOTT
18, Rue Servandoni

PARIS 6ᴱ LITTRE 74·63

1927

Meets Julien Levy. Abbott makes two portraits of Atget. He dies on August 4. His executor, Calmettes, sells two thousand of his prints to the Monuments Historiques. Abbott acquires about five thousand prints and thirteen hundred negatives, which eventually go to the Museum of Modern Art, New York.

1928–29

Atget's photographs are occasionally published in periodicals; some are exhibited in the Salon des Indépendants exhibition.

1930

Abbott arranges publication of the first monograph devoted to Atget's work, with a preface by Pierre Mac-orlan. Levy mounts an exhibition of Atget's work in New York.

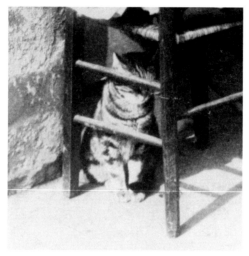

Eugène Atget.
Costume Shop, rue de la Corderie,
negative: 1911; print: circa 1920
(pl. 24, detail).

Editor	Gregory A. Dobie
Designer	Jeffrey Cohen
Production Coordinator	Stacy Miyagawa
Photographers	Charles Passela
	Ellen M. Rosenbery
	Rebecca Vera-Martinez
Printer	Gardner Lithograph
	Buena Park, California
Bindery	Roswell Bookbinding
	Phoenix, Arizona